MARGOT FONTEYN

MARGOT FONTEYN

PRIMA BALLERINA ASSOLUTA OF THE ROYAL BALLET

EDITED BY CRISTINA FRANCHI

OBERON BOOKS
LONDON

First published in 2004 by the Royal Opera House
in association with Oberon Books Ltd

Oberon Books
521 Caledonian Road, London N7 9RH
Tel 020 7607 3637 Fax 020 7607 3629
oberon.books@btinternet.com
www.oberonbooks.com

Compilation copyright © Royal Opera House 2004
Text copyright © Royal Opera House 2004
Photographs copyright © the copyright holders

The Royal Opera House and Cristina Franchi are hereby identified as
authors of this book in accordance with section 77 of the Copyright,
Designs and Patents Act 1988. The authors have asserted their moral
rights.

ISBN 1 84002 460 7

Cover and book design: Jeff Willis

Publication Assistant: Renata Bailey

Acknowledgements: Cristina Franchi would like to thank all the
photographers and copyright holders who have allowed us to share their
wonderful images. She would also like to thank designer Jeff Willis, Dan
Steward and Stephen Watson at Oberon, Georgina Matthews at Team
Photographic and at the Royal Opera House Monica Mason, Jeanetta
Laurence, Anne Bulford, Francesca Franchi, Renata Bailey, Samya
Waked and Tom Tansey, without whom this book would not have been
possible.

Printed in Great Britain by Antony Rowe Ltd, Chippenham.

Photographic Credits

Gordon Anthony, Theatre Museum, Victoria & Albert Museum 7, 17, 21, 23,
 25, 27, 28, 31, 33, 35, 36, 37, 39, 41, 42, 43, 44
Baron, Hulton Deutsch 52, 54, 55 above, 64
Barratt's Photo Press 81 below
Camera Press 79 below
Bill Cooper 130 above
Anthony Crickmay, Theatre Museum, Victoria & Albert Museum 112 below
Pigeon Crowle 16
Frederika Davis 91, 92 all, 93, 94, 96, 97 both, 98 both, 99, 100 both, 102,
 103, 104, 105 both, 109, 118 below left, 119 below, 121 both, 122 all,
 123 all
Mike Davis 108, 120 above
J W Debenham, Theatre Museum, Victoria & Albert Museum 19, 22, 26, 29,
 32, 34, 38
Zoë Dominic 89, 90
Leslie Edwards Collection 48 below, 49 above, 76 above, 82 above
Roy Fisher 115
Felix Fonteyn, Royal Opera House Archives 66, 67, 68, 69, 82 above left and
 right
Felix Fonteyn 61, 82 below, 119 above
Margot Fonteyn Collection, Royal Opera House Archives 8, 10, 11, 12, 13, 15,
 19, 30, 33, 35, 48 above, 53, 60, 67, 74, 77 both, 87, 101 above, 119
 above, 124 below, 126 both
Fox Photos 46 both
Sy Friedman 80 below
Eric Gray 18
Harry P Hider 9
Shuhei Iwamoto 106
Celesta, D S Jhdanova 14
Germaine Kanova 53
John T Knight 51
E Lucas 47 below
Edward Mandinian 20, 50, 55 below, 79 above
Angus McBean, courtesy of Harvard Theatre Collection, Harvard University
 Library 6, 62
Luis Perez 126
Carl Perutz – Magnum, Magnum Photos 63
Pictorial Press 83
Rank 116
Royal Ballet Benevolent Fund Collection, Royal Opera House Archives 32, 43,
 69
Richardby 58
Roy Round 114, 120 below
Houston Rogers, Theatre Museum, Victoria & Albert Museum front cover,
 inside front, 59, 71, 72, 73, 74, 117
Donald Southern Collection, Royal Opera House Archives 109, 110, 111, 124
 above, 127 both, 129 below, 130 below, 131, inside back
Leslie E. Spatt 88, 95, 101, 107, 113, 118 below right, 128 both, 129 above
The Sports & General Press Agency 45
Tunbridge-Sedgwick 40, 70
Jennie Walton 124 below, back cover
Hans Wild 57
Rosemary Winckley 112 above
Roger Wood 56, 65, 75, 80 above, 81 above, 84, 85, 86

Every effort has been made to trace the photographers of all pictures reprinted in
this book. Acknowledgement is made in all cases where photographer and/or
source is available.

CONTENTS

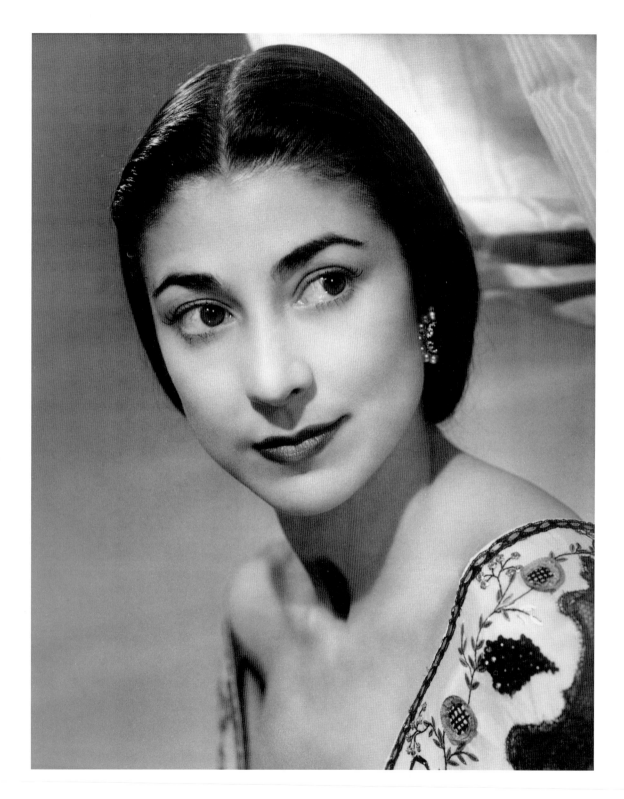

Portrait of Margot Fonteyn by Angus McBean

FOREWORD

I am delighted to have the opportunity to introduce this book, which celebrates Margot Fonteyn's extraordinary career with The Royal Ballet. I was a member of the company from 1942 until 1956 and it is with the warmest affection that I remember Margot. She was such an example to us all during those early days in the 1940s and 50s, exhibiting no airs about her ballerina status. She showed such generosity to all of us. At Christmas, she bought each member of the Company a present – so thoughtfully chosen, varied for each individual. I danced quite a few of Margot's roles and Frederick Ashton asked me to understudy some of the roles he created for Margot. I attended rehearsals at their creation and even shared some of her costumes. At no point when Ashton was choreographing do I remember Margot showing any temperament, other than her infectious giggle – especially in response to attempts to execute some difficult 'lift' (usually, in the capable hands of Michael Somes), after which it would be tried time and time again, always with the same happy responsive laugh.

My own personal memory comes from Detroit, where I rehearsed long and hard to dance Margot's role in *Homage to the Queen*. The theatre manager insisted Margot perform that night, since her appearance in the role had been advertised and, as a consequence, all seats were booked. I arrived at the theatre – a bundle of nerves, anticipating my performance – and was handed a yellow slip of paper informing me about the change of cast. When, with great despondency, I arrived at my place in the dressing room, I found a note from Margot saying how very sorry she was – and a little bottle of *Arpége* perfume. Dearest Margot, how that lifted my heart! How we willed her to success on special occasions. She always rose to the occasion on first nights – how we applauded her!

It saddens me to hear that some present day students, who never saw her perform, are critical that she didn't share their attributes of loose legs, elevation, and beautiful insteps – little do they know what they missed. Her 'line' of arabesque – even when at odd times it lacked complete 'turn out' – was so beautiful, one might liken it to a poem. Her proportions were so perfect for a dancer and, watching her at close quarters, the expressiveness of her shoulders and back transmitted all the emotions she wanted to communicate to her audience – they were so truly heartfelt. No unnecessary frills or mannerisms – delicate little hand movements, so beautifully expressive in *Wise Virgins* and *Ondine*; the perfect timing in her interpretation of each note of music; the carefree use of her arms when youthful in roles – all added up to a magic no one could surpass. You couldn't look at anyone else on stage while she was performing.

Dear Margot – how we miss you!

Pauline Clayden

Pauline Clayden as A Flower Girl in *Nocturne*, 1946, one of the roles created by Frederick Ashton for Margot Fonteyn

THE YOUNG DANCER

Margot Fonteyn was born Margaret Hookham on 18 May 1919 and was known to her family and friends as Peggy. Her father Felix Hookham was from Yorkshire and her mother had an Irish mother and Brazilian father. It was from her Brazilian grandfather that Peggy later derived her stage name of Fontes, when Peggy Hookham became Margot Fonteyn. Peggy had one brother, Felix, who was three years older than her. Felix was also to later adopt the Fonteyn name professionally for his work as a dance photographer. The family lived in Ealing, London and Peggy took her first dance lessons with Grace Bosustow, who ran a small dance Academy in Ealing. Peggy made her debut as a 'Wind' in the babies' ballet aged four. She enjoyed her dance classes and school performances, particularly the character dances, and passed her dance exams with honours.

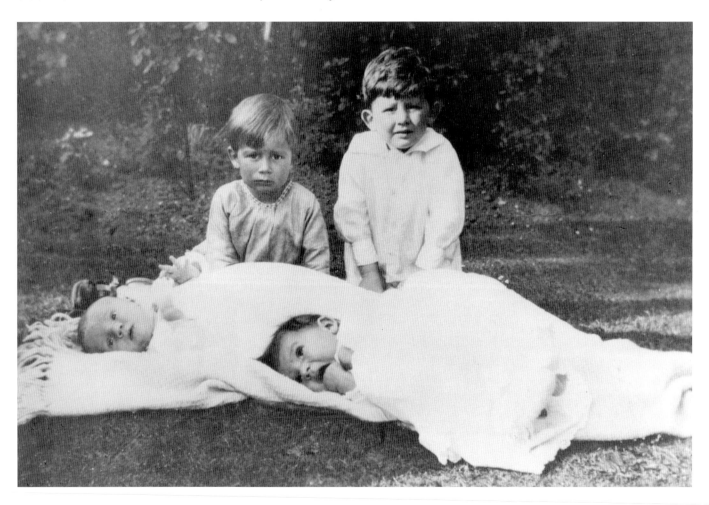

Peggy Hookham as a baby (centre); her brother Felix can be seen on the right

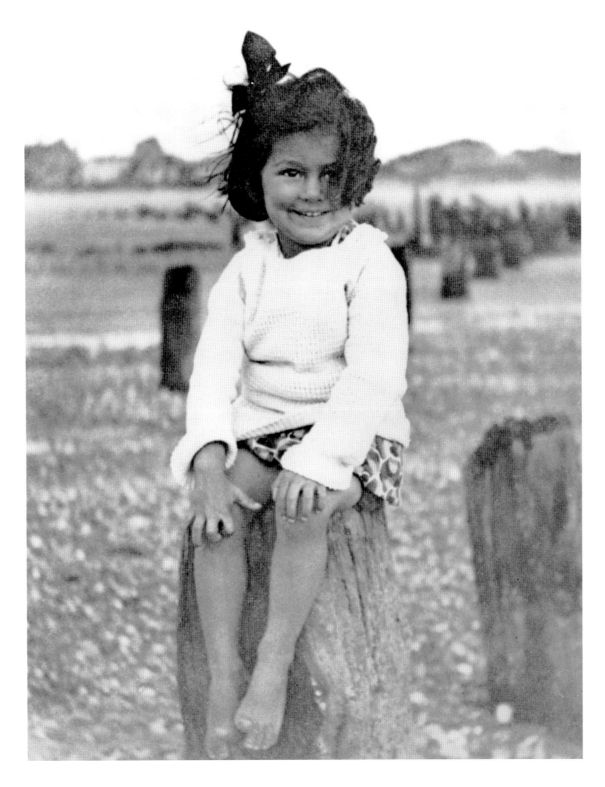

Peggy aged about five sitting on a groyne at the seaside

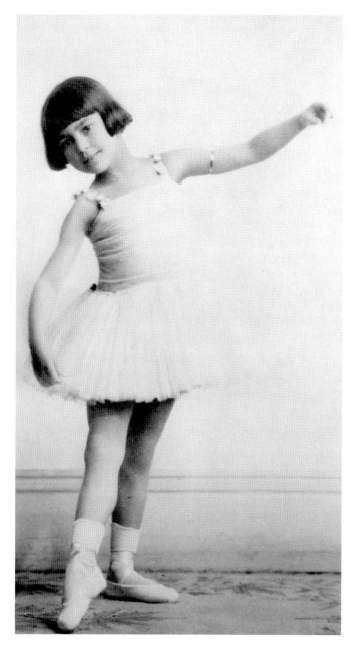

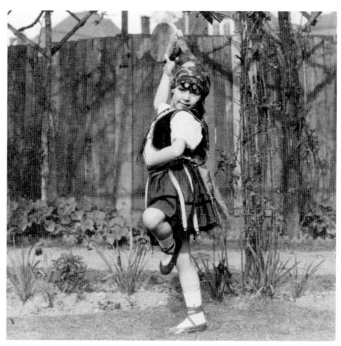

The young ballerina. The photographs in the garden were taken in April, 1926 at her home in Ealing, London.
The six year old can be seen as Red Riding Hood (below) and in a tambourine dance (above)

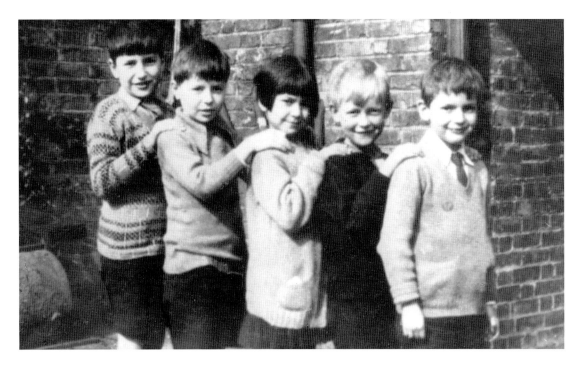

above: Peggy (centre) at school at the Cane's, Ealing Common, March 1927
below: Peggy and her brother Felix, Ventnor, September 1929

In 1927, Felix Hookham was offered a job as Chief Engineer for the British Cigarette Company in Shanghai so the family moved to China, settling first in Tientsin in 1928 and then in Shanghai. Felix junior stayed behind at school in England and Peggy and her mother made long trips home to visit him.

Peggy continued with her dance classes, first with Madame Tarakanova in Tientsin and then with George Gontcharov in Shanghai, and appeared regularly in ballet shows. In Shanghai, Peggy became friends with a fellow dance student June Brae and when Mrs Brae decided to take June to London for classes, Peggy and her mother followed them.

Mrs Hookham took the 14 year old Peggy to have lessons with Princess Astafieva, who was Alicia Markova's teacher. Peggy enjoyed her classes with Astafieva and was quite upset when her mother wanted her to audition for the Vic-Wells Ballet School. However, Mrs Hookham realised that if Peggy was to have the chance of a career as a dancer, she needed the opportunities the Vic-Wells School could give her. Accordingly, in 1934 they took the bus up Rosebery Avenue to Sadler's Wells Theatre to an audition with Ursula Moreton and Peggy was accepted into the Vic-Wells Ballet School.

Peggy and her father Felix Hookham

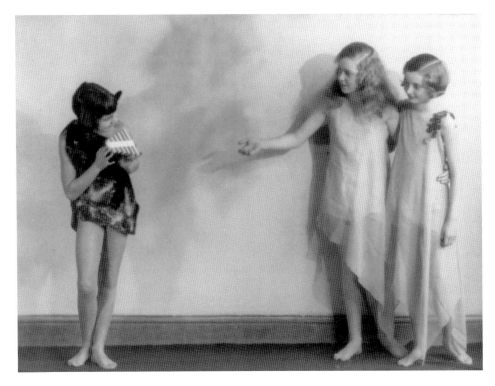

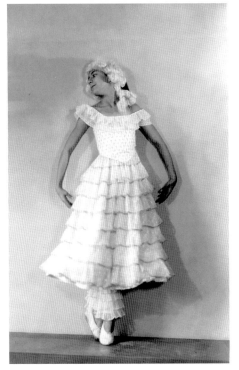

Dancing in Shanghai
above: Peggy (left) at the Romer-Peeler Greek Dancing School

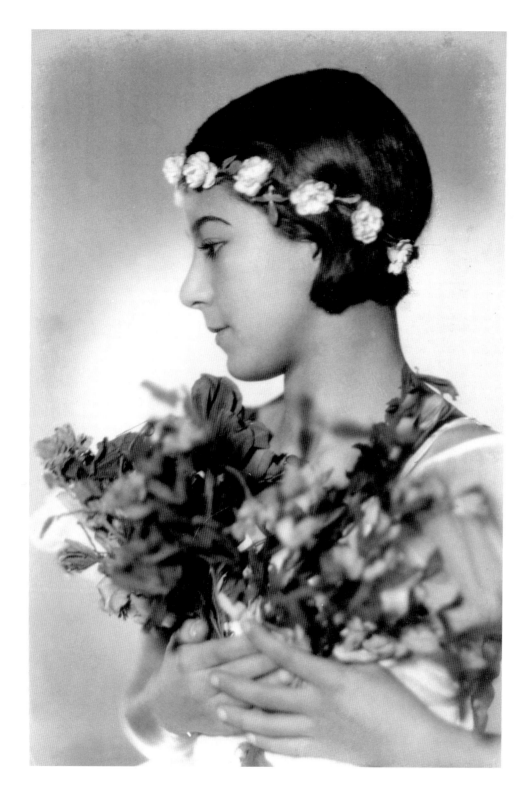

In costume for *Les Sylphides,* Shanghai, 1933

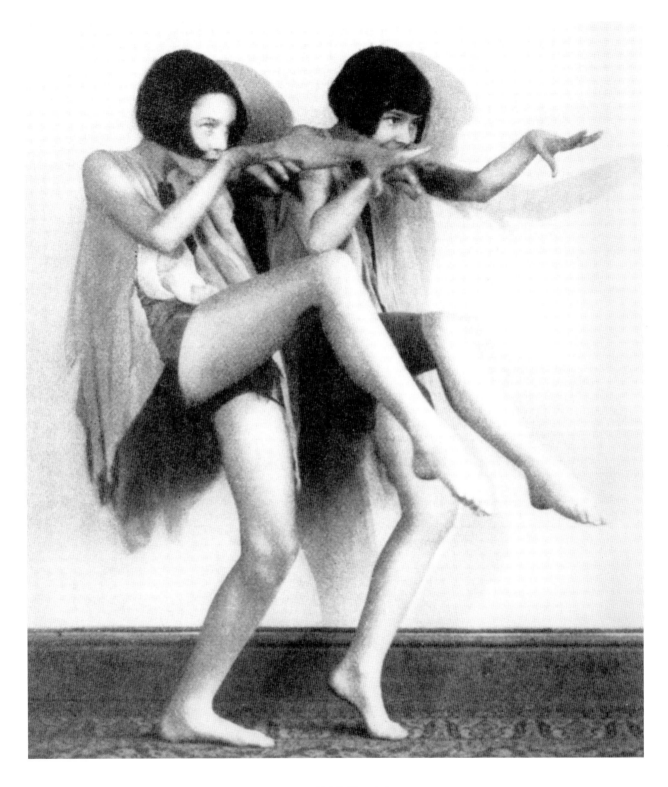

Peggy (right), Shanghai

JOINING THE VIC-WELLS BALLET
'SOMETHING WONDERFUL AND BEAUTIFUL HAD COME INTO OUR MIDST'

The Vic-Wells School was based with the Company at Sadler's Wells Theatre. They did class in the Wells room and, shortly after Peggy joined, Ninette de Valois visited the Junior Girls Class to see how the new arrivals were coming on. She later recalled how she spotted 'Little Hookham', a 'lovely child…with her elegant limbs and well poised head'. She thought she looked Chinese and there was some confusion when she heard Peggy had been living in Shanghai. 'Chinese or not it was obvious that something wonderful and beautiful had come into our midst.'

Members of the School took part in performances by the Vic-Wells Ballet and Peggy soon found herself on stage as a snowflake in *Casse-noisette*. Her first named role followed when she appeared aged 14 as Young Treginnis in *The Haunted Ballroom*. A small mime role, she had to open and close the ballet alone on stage. It was pointed out that Peggy Hookham was not the most sonorous of names for a ballerina so she appeared in the programme as Margot Fontes. Shortly after this, her name was changed to Margot Fonteyn the beginning of the process whereby 'Little Hookham, who answered to the name of Peggy, grew up into Margot Fonteyn'.

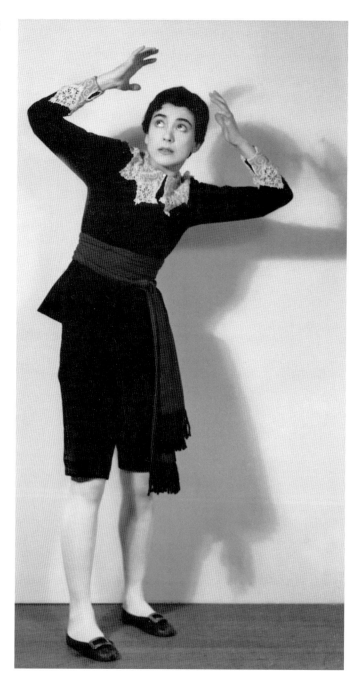

Margot Fontes as Young Treginnis in *The Haunted Ballroom*, 1934
her first named role with the Vic-Wells Ballet

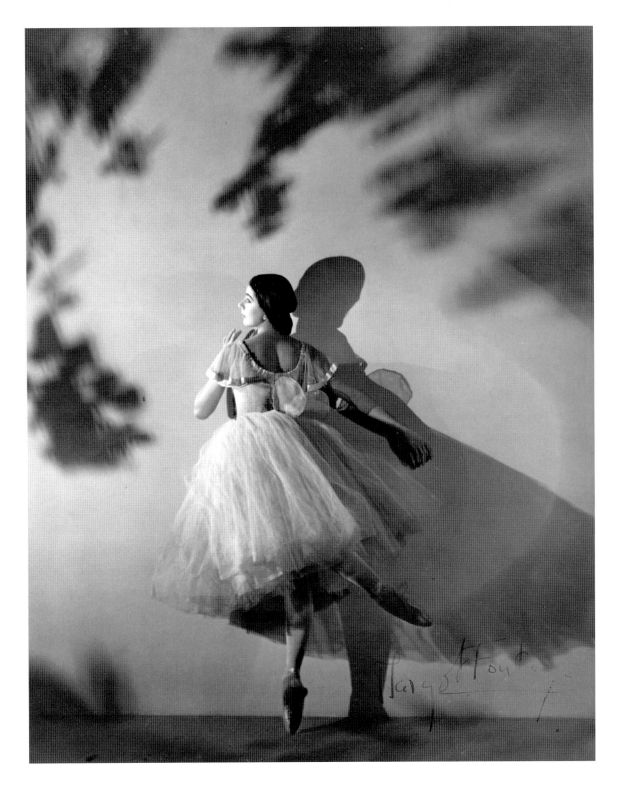

Margot Fonteyn in *Les Sylphides*, 1935

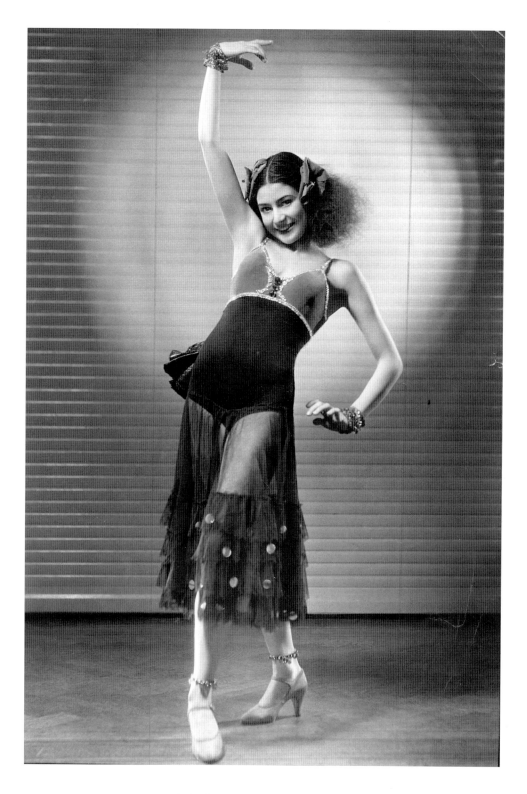

As the Creole Girl in *Rio Grande*, 1935

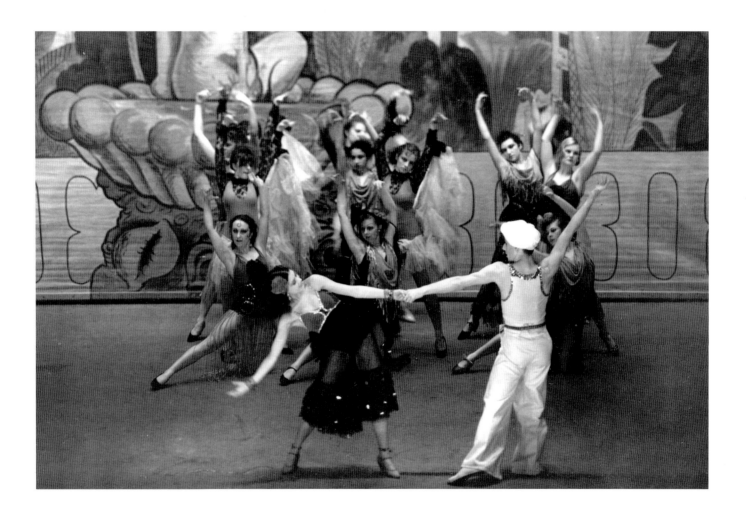

As the Creole Girl with William Chappell
as the Creole Boy in *Rio Grande,* 1935

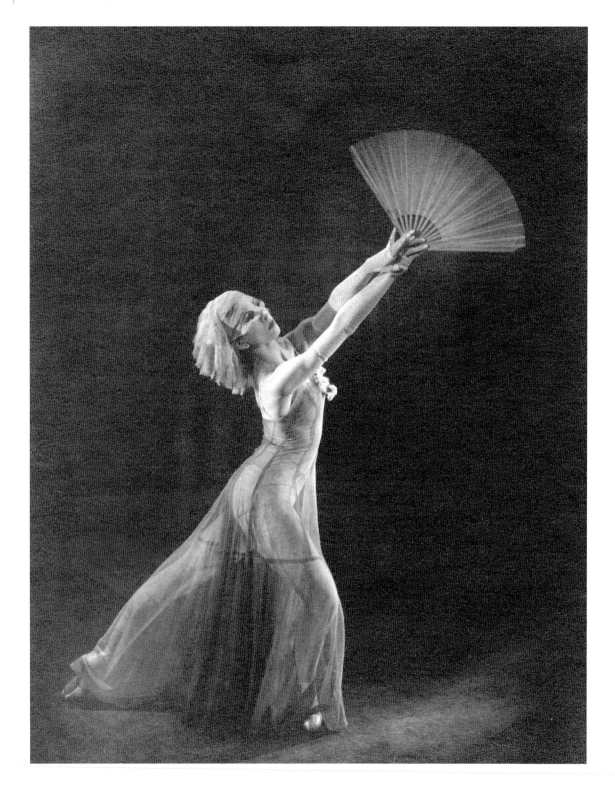

As Alicia in *The Haunted Ballroom*, 1945

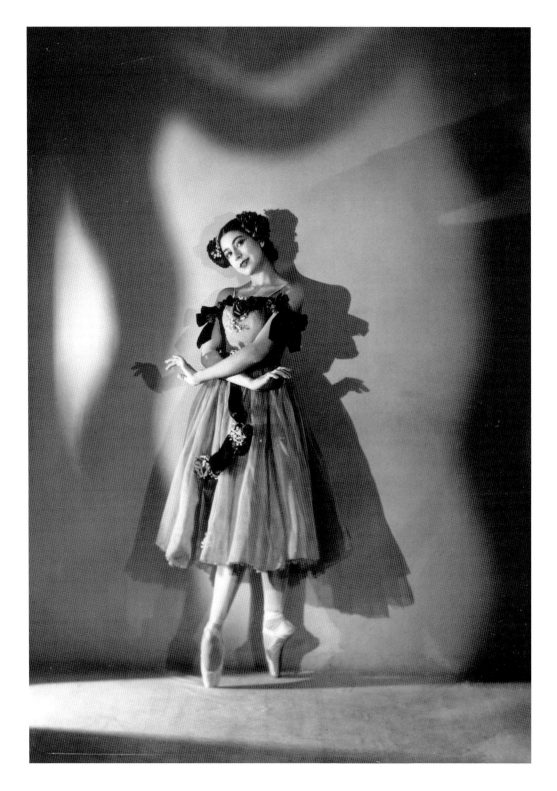

Les Rendezvous, 1935

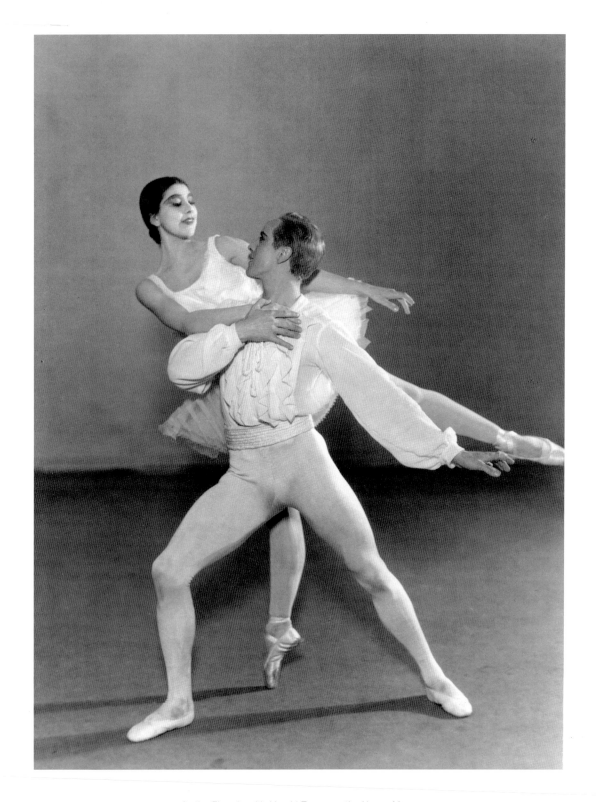

As the Fiancée with Harold Turner as the Young Man
in *Le Baiser de la fée*, 1935
This was the first role created on Fonteyn by choreographer Frederick Ashton

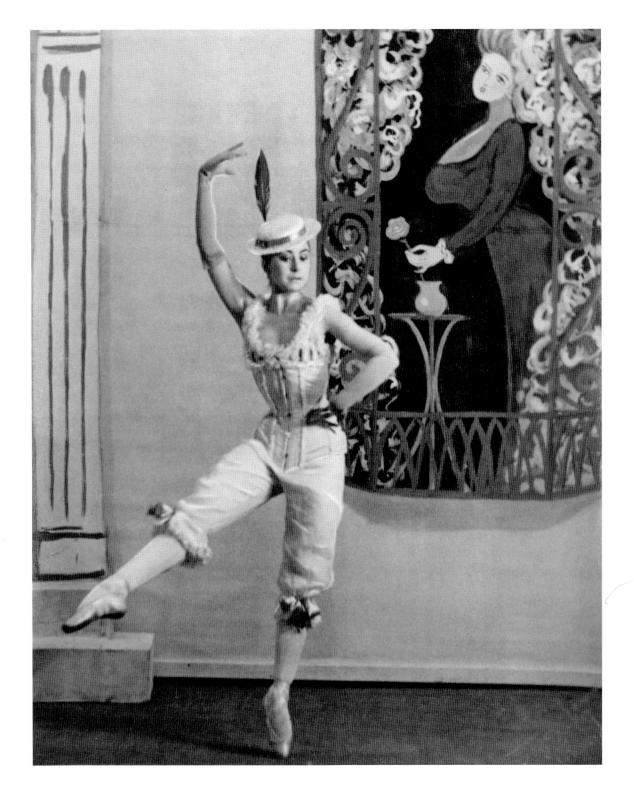

The Polka from *Façade*

In 1935, the Company's Resident Choreographer Frederick Ashton created his first role on Fonteyn as the Fiancée in *Le Baiser de la fée* and this was to be the beginning of an extraordinary creative partnership. The following year he created roles for her in *Apparitions* and *Nocturne*. 1936 also saw the beginning of Fonteyn's 14-year partnership with the great Australian dance actor Robert Helpmann. Fonteyn has described how, 'in *Apparitions* the harmony of dancing with Robert Helpmann began taking hold'. She always found him considerate and patient as a partner, even in the early days when she was very inexperienced. Helpmann was a magnetic stage personality and, dancing with him, Fonteyn had to learn how to hold her own on stage.

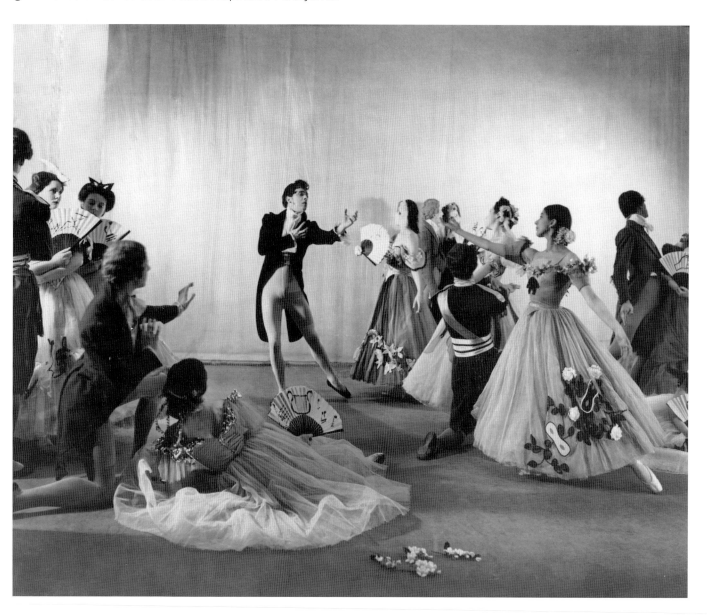

Robert Helpmann (centre back) as The Poet and Fonteyn (right)
as The Woman in Ball Dress in *Apparitions,* 1936

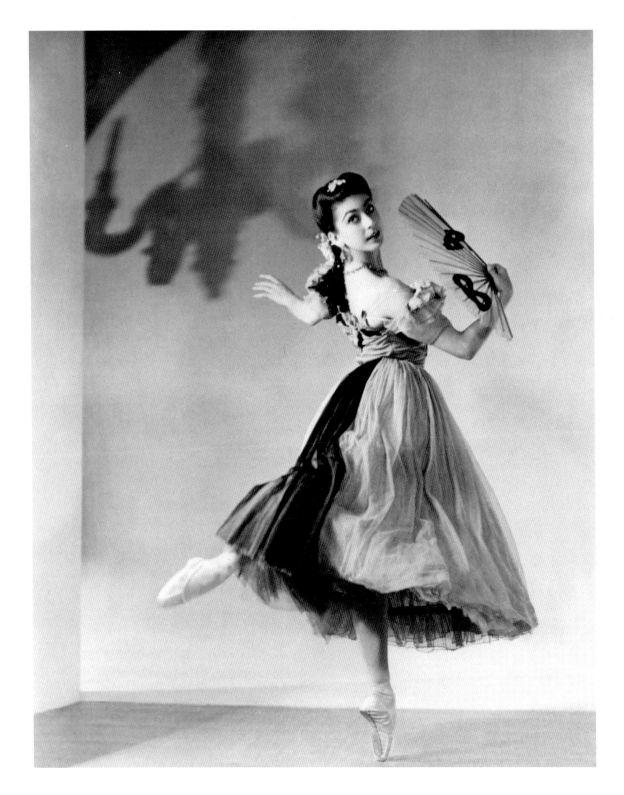

As The Woman in Ball Dress in *Apparitions,* 1940

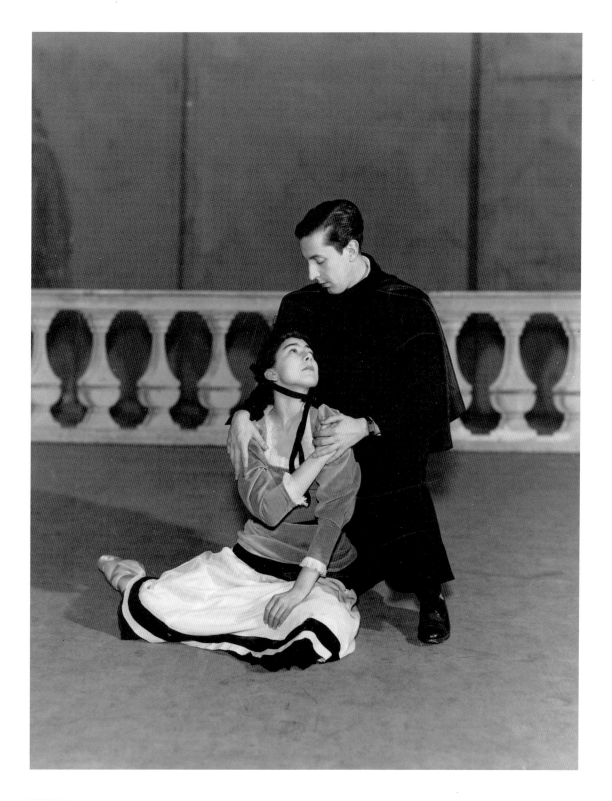

As A Flower Girl with Frederick Ashton
as A Spectator in *Nocturne,* 1936

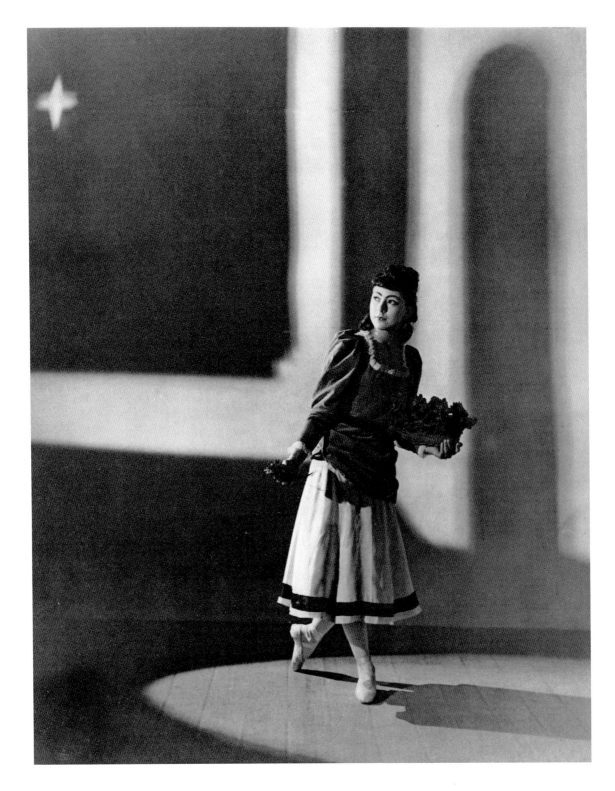

As A Flower Girl in *Nocturne*, 1936

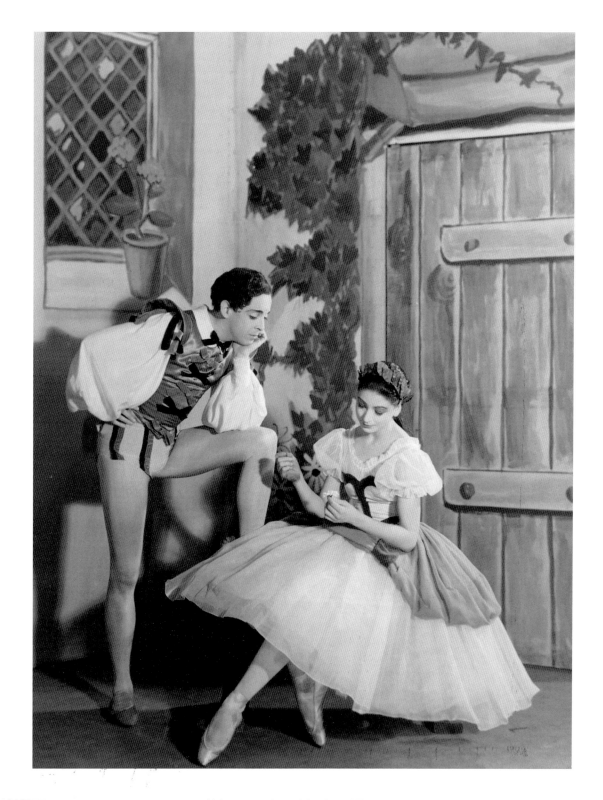

Helpmann as Count Albrecht and Fonteyn
as Giselle in Act I of *Giselle*, 1937

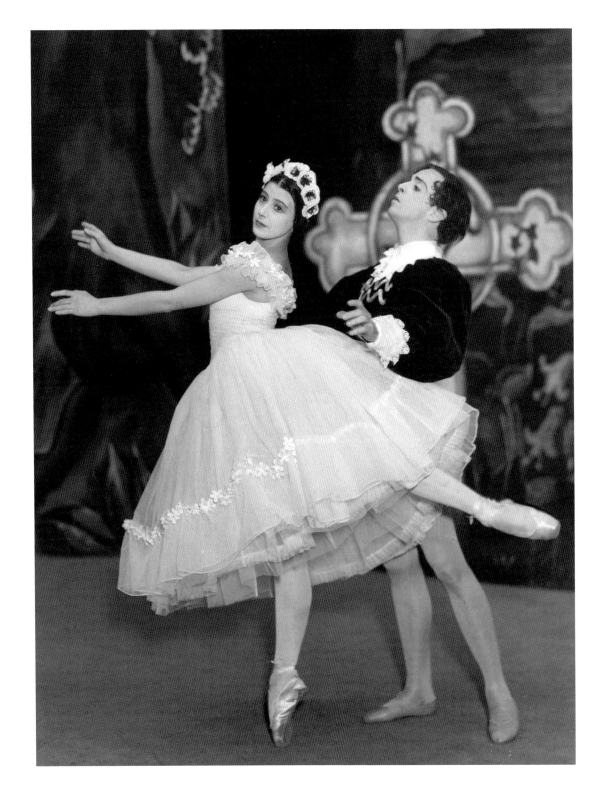

Giselle Act II, 1937

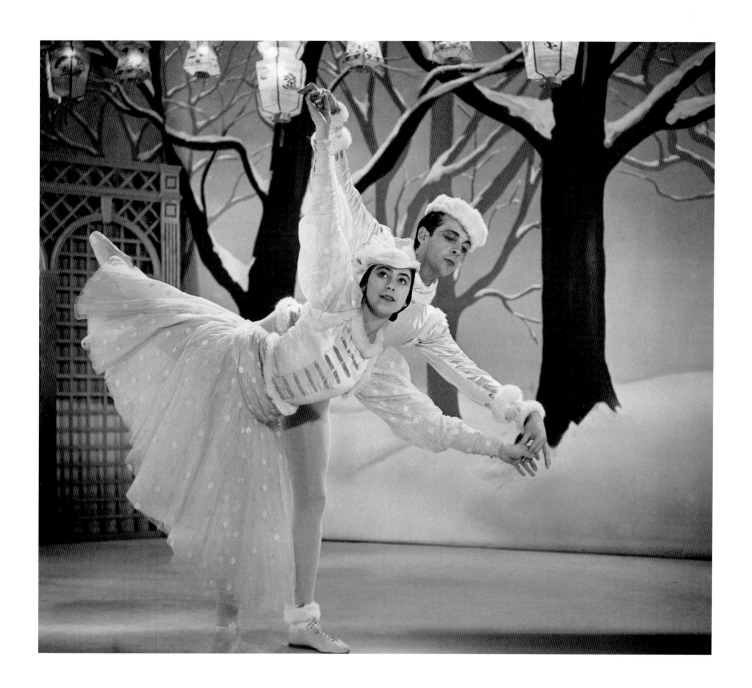

With Helpmann in the *pas de deux* from *Les Patineurs,* 1937

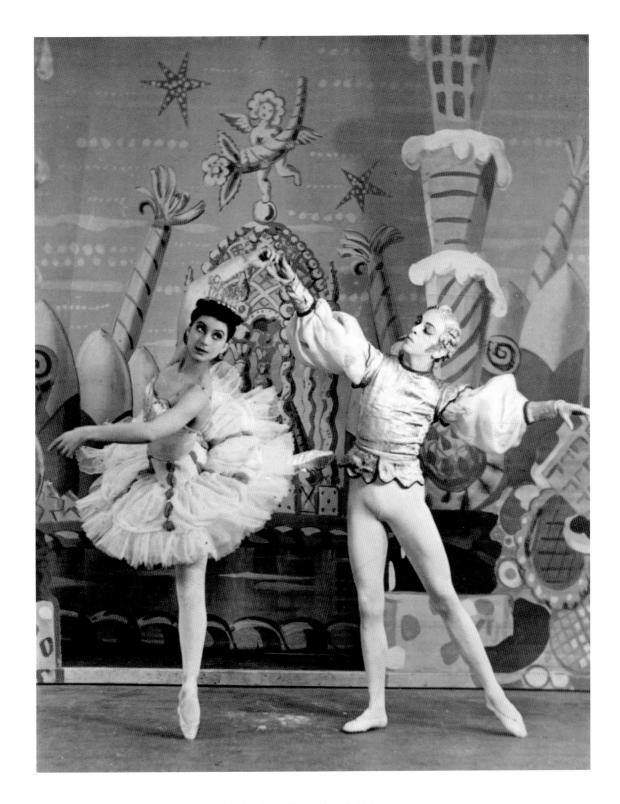

As the Sugar Plum Fairy with Helpmann
as the Prince in *Casse-noisette*, 1937

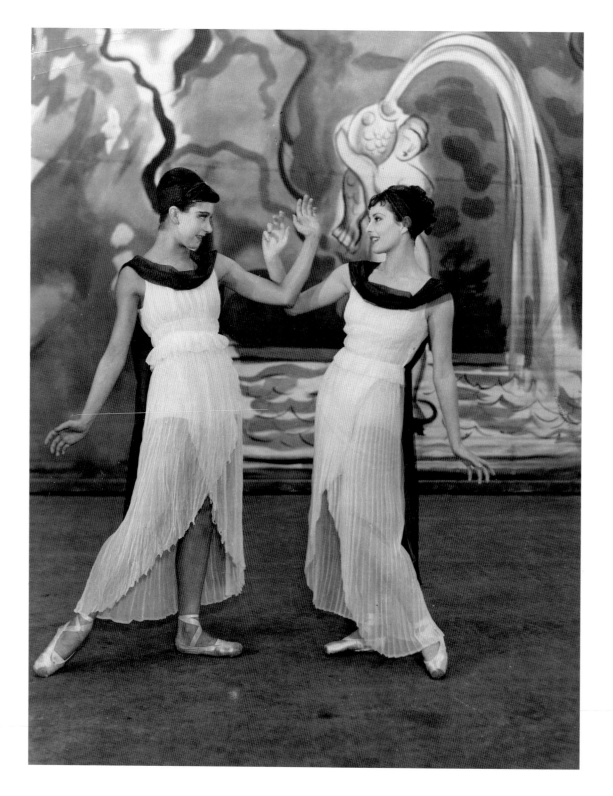

Fonteyn (left) and Pearl Argyle in *Pomona*, 1937

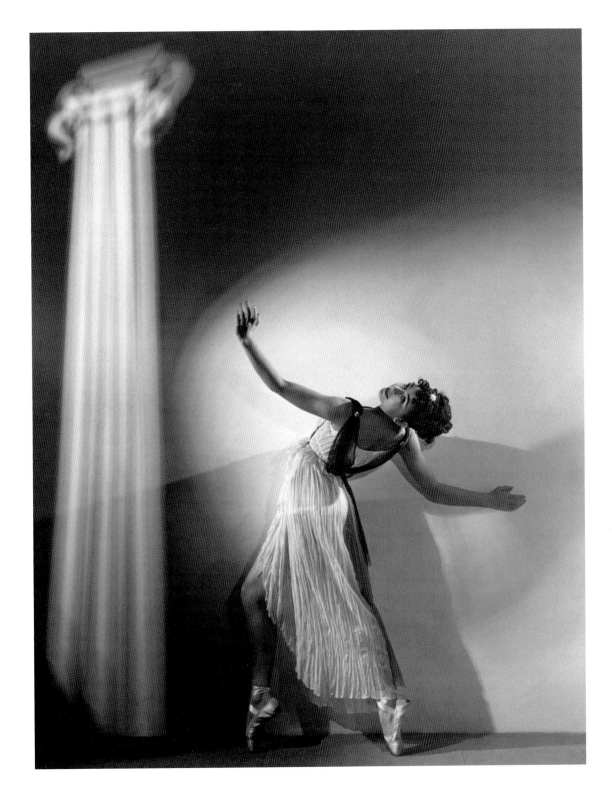

Pomona, 1937

Michael Somes joined the Vic-Wells Ballet in February 1935 aged 17. De Valois thought him very talented and it was soon clear that here was a young man who was going to go far. He was serious and hard-working, with an unusual ability to leap high. Ashton created the roles of the lovers in *Horoscope* on Fonteyn and Somes. It was the first time they had been partners and it was to be the beginning of a great partnership.

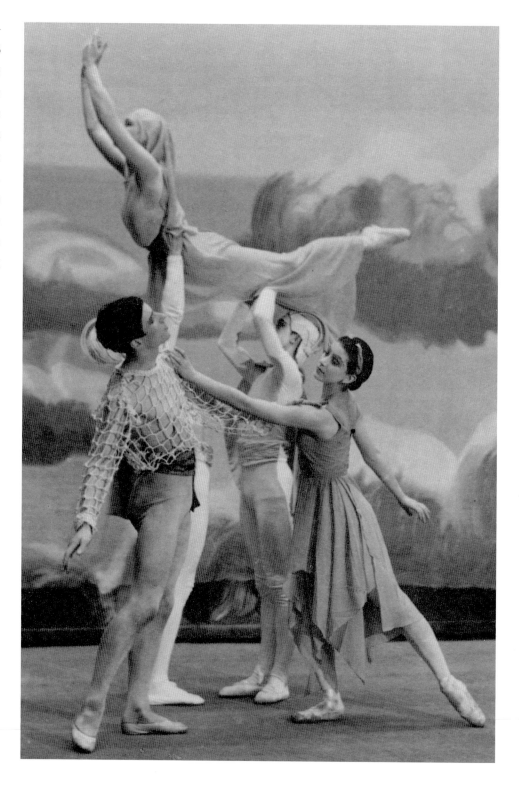

Michael Somes and Fonteyn (in front)
with Pamela May and Alan Carter in *Horoscope*, 1938

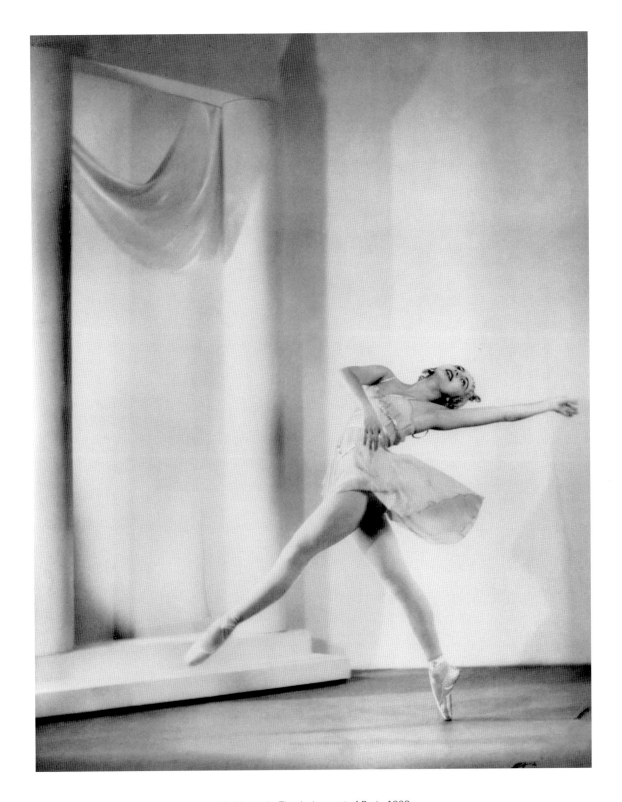

As Venus in *The Judgement of Paris*, 1938

The Vic-Wells Ballet was led for a time by the great ballerina Alicia Markova. In 1936 she left to start her own company with her partner Anton Dolin. De Valois could have looked for another established ballerina but she decided that the future of the Vic-Wells Ballet lay in the 17 year old Margot Fonteyn. Fonteyn had already danced her first Odette a year earlier. Her amazing progression continued as she danced her first Giselle at 17, took on the full length *Swan Lake* when she was 18 and Princess Aurora in *The Sleeping Princess* at the age of 19.

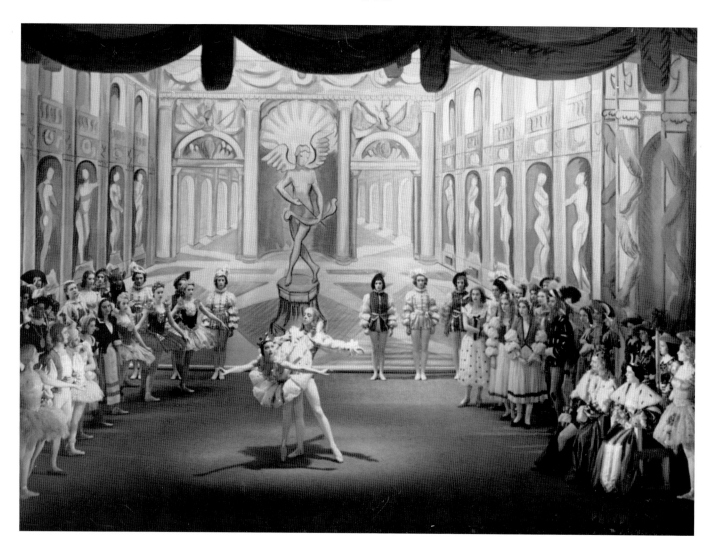

Fonteyn as Princess Aurora and Helpmann as Prince Charming
with the Vic-Wells Ballet in Act III of *The Sleeping Princess*, 1939

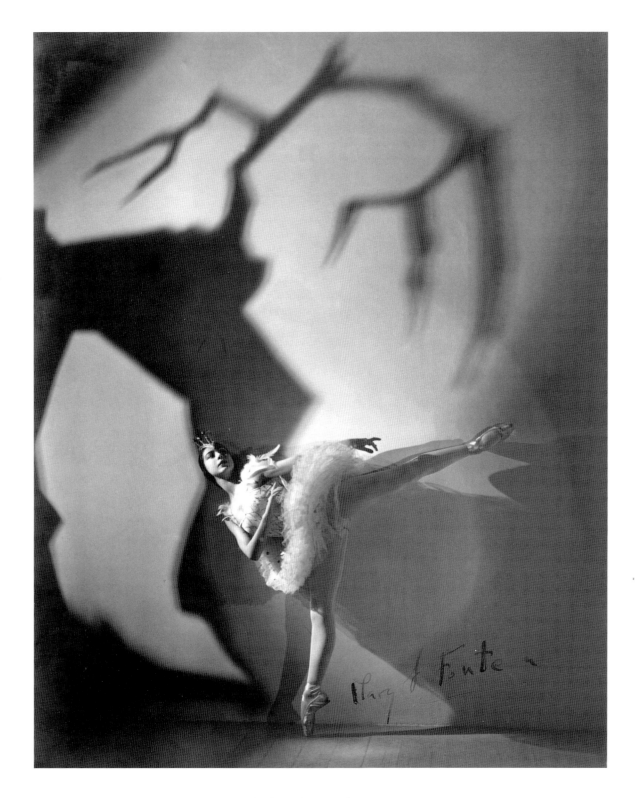

As Odette in *Le Lac des cygnes*

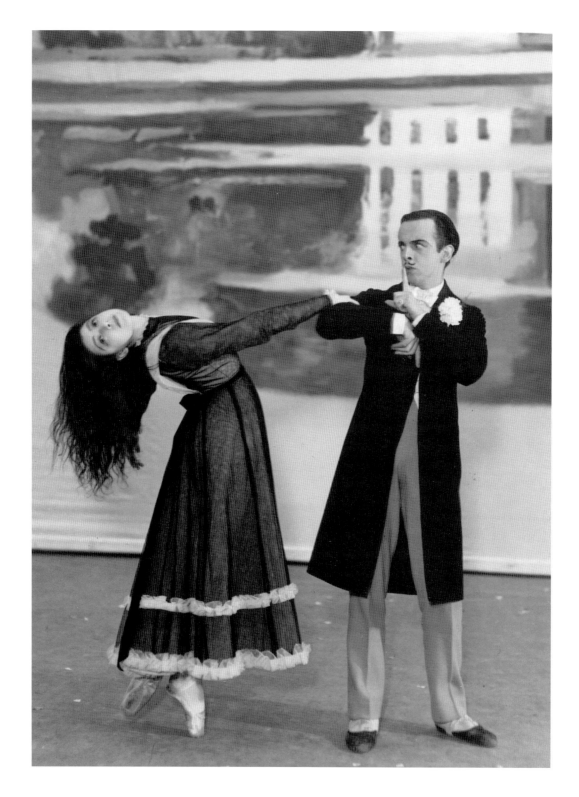

Fonteyn as Julia and Helpmann as the Bridegroom
in *A Wedding Bouquet,* 1937

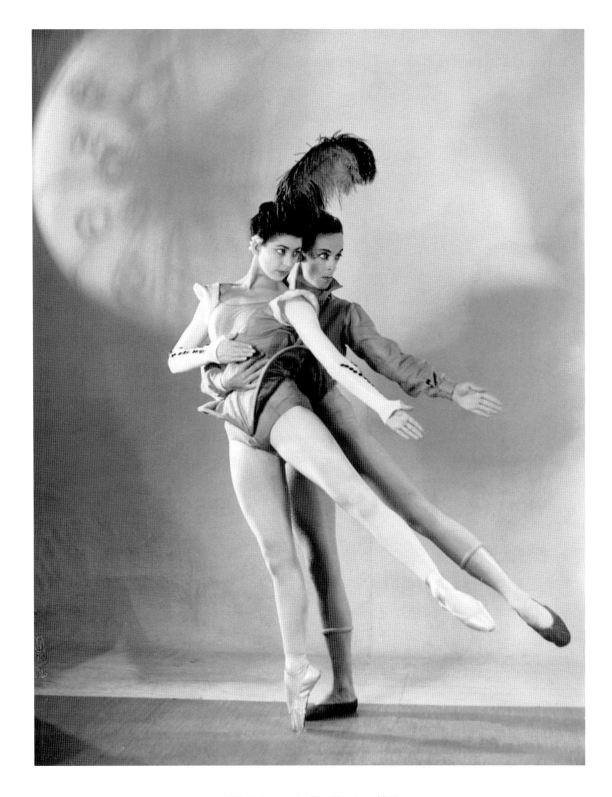

With Helpmann in *The Wanderer*, 1941

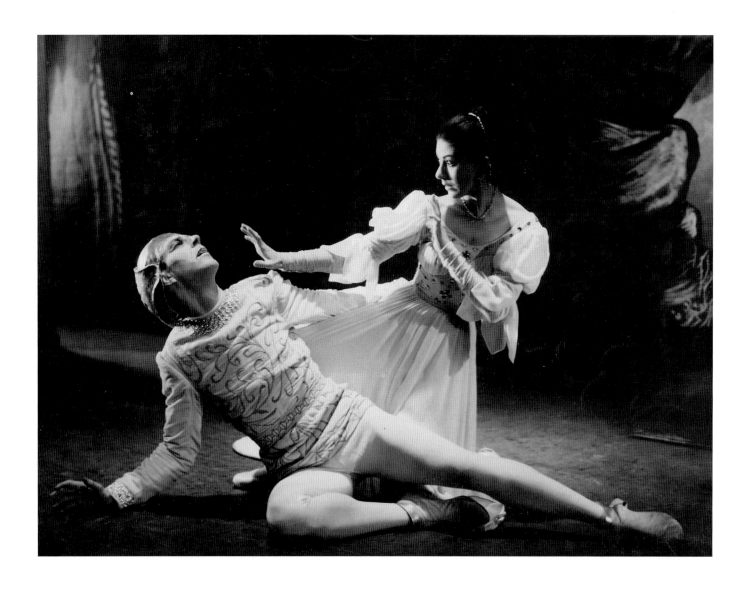

Leslie Edwards as Archimago and Fonteyn
as Una in *The Quest*, 1943

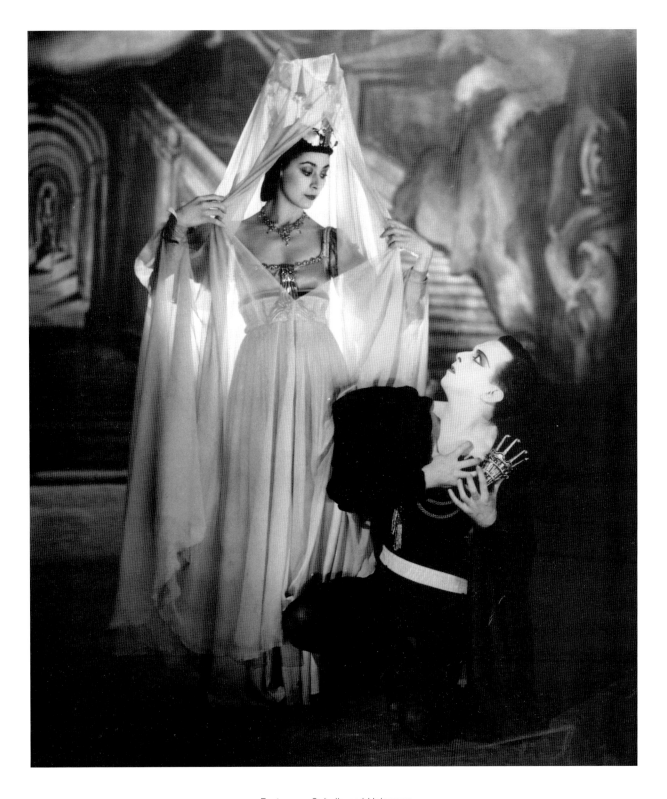

Fonteyn as Ophelia and Helpmann
as Hamlet in *Hamlet,* 1942

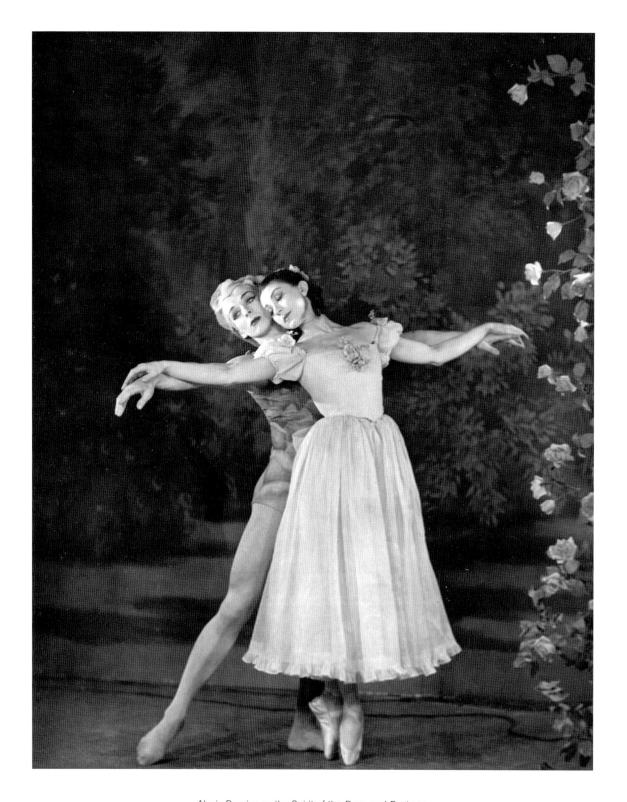

Alexis Rassine as the Spirit of the Rose and Fonteyn
as the Young Girl in *Le Spectre de la rose*, 1944

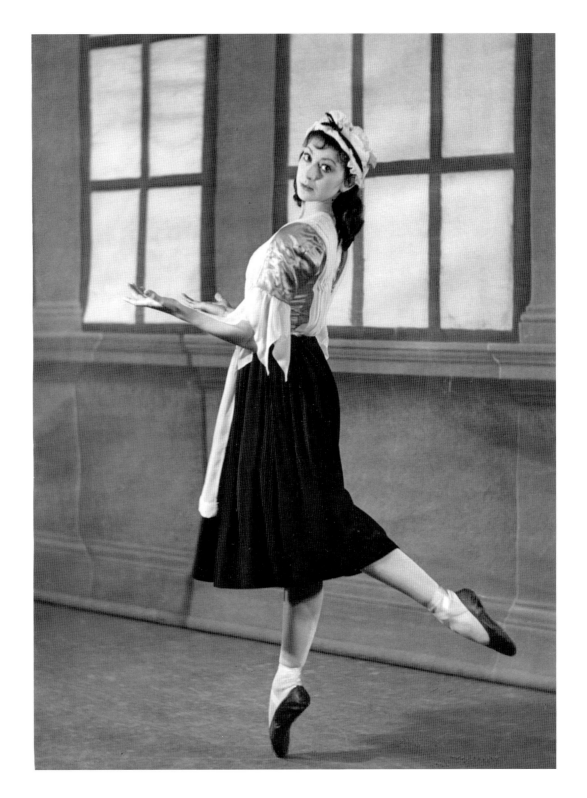

As The Betrayed Girl in *The Rake's Progress*, 1942

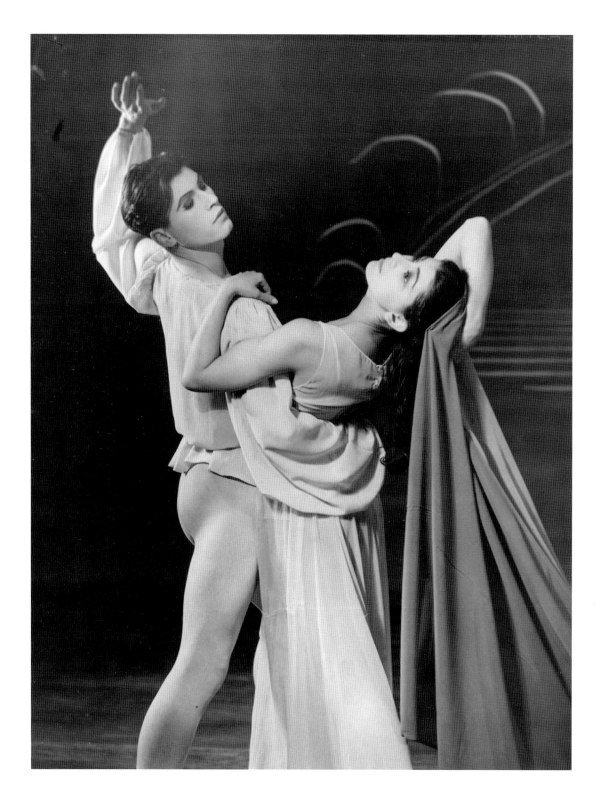

Somes and Fonteyn as Children
of Light in *Dante Sonata*, 1940

LIFE BEHIND THE SCENES IN THE 1930s AND EARLY 1940s

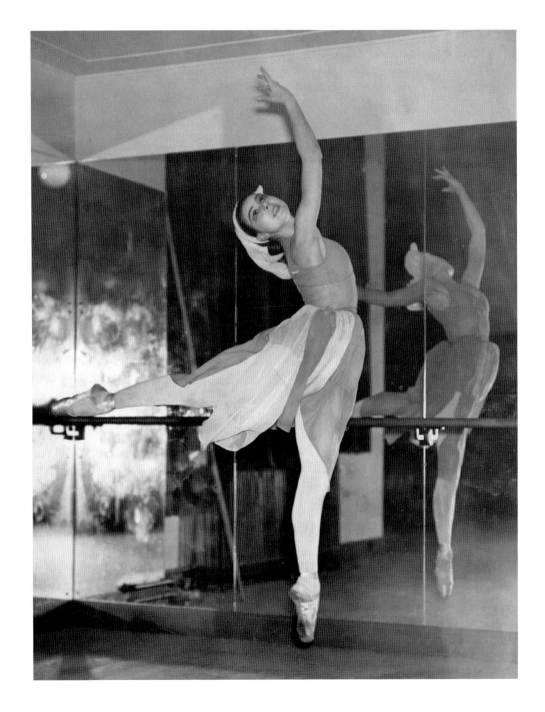

In rehearsal as The Young Woman
in *Horoscope*, 1938

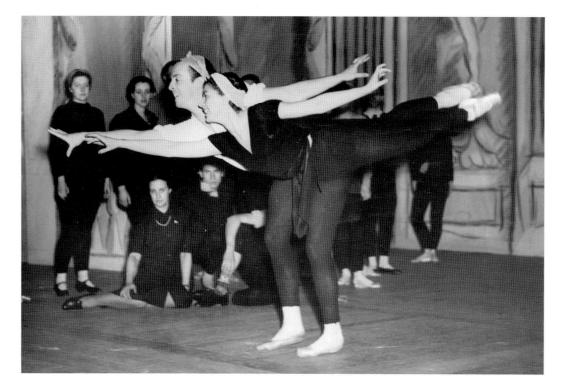

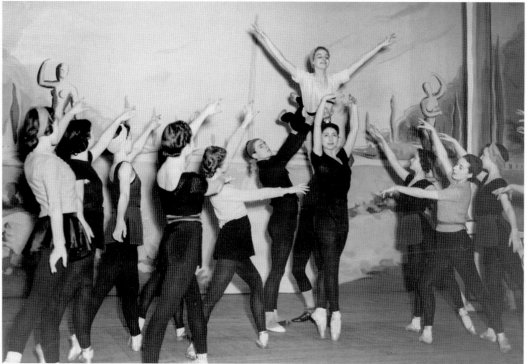

The Vic-Wells Ballet in rehearsal for *The Sleeping Princess*
above: Fonteyn and Helpmann

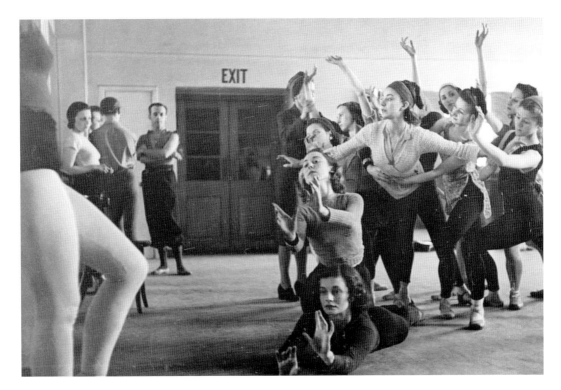

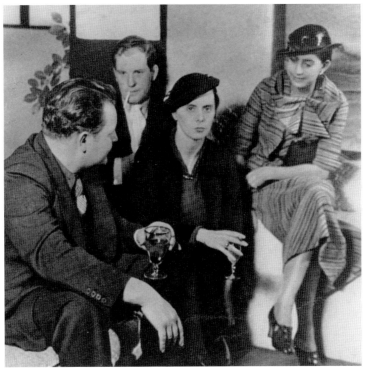

above: Ninette de Valois (partially obscured at the back)
in rehearsal with Vic-Wells Ballet; Margot Fonteyn can be seen in the centre
below, left to right: Constant Lambert, Gordon Anthony, Ninette de Valois and Margot Fonteyn
at the launch of Anthony's new photographic studio. Anthony was de Valois' brother.

The Vic-Wells Ballet appeared twice yearly in week-long seasons at the Cambridge Arts Theatre. This caused much excitement among the under-graduates, who enjoyed their company and threw many parties for them. It was during the June 1937 tour that Fonteyn met a young Pana-manian, Harmodio Arias, known as Tito. They were to meet again occasionally over the next few years but it would be nearly another twenty years before they married.

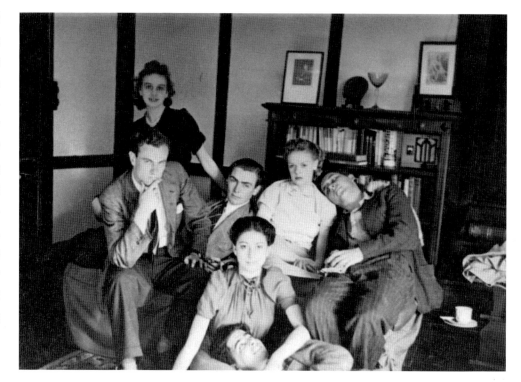

above: Fonteyn and Harmodio Arias (in front) with David Breeden, Painton Cowan, Pamela May and Derek Prince, Cambridge, June 1937
below: Fonteyn and Pamela May

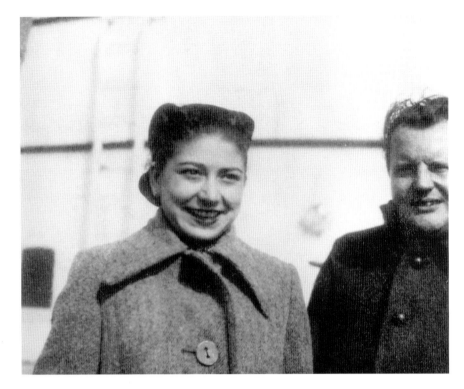

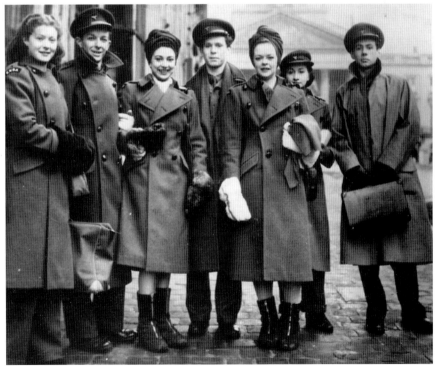

On Tour: *above:* Fonteyn and Constant Lambert
below: Sadler's Wells Ballet ENSA tour to Brussels, 1945
left to right: Moira Shearer, Alexis Rassine, Margot Fonteyn, Douglas Steuart,
Pamela May, Elizabeth Kennedy and Eric Hryst

SADLER'S WELLS BALLET FROM 1946
'PRINCESS AURORA COMES INTO HER KINGDOM'

Sadler's Wells Ballet made the Royal Opera House its home in 1946. It was fitting that Margot Fonteyn as Princess Aurora in a new production of *The Sleeping Beauty* should awaken the theatre after its war-time service as a Mecca dance hall. Princess Aurora was one of Fonteyn's greatest roles and, partnered by Robert Helpmann as Prince Florimund, in the words of Ninete de Valois 'she came into her kingdom'. The performance on 20 February 1946 was attended by the King and Queen with their young daughters, the Princesses Elizabeth and Margaret.

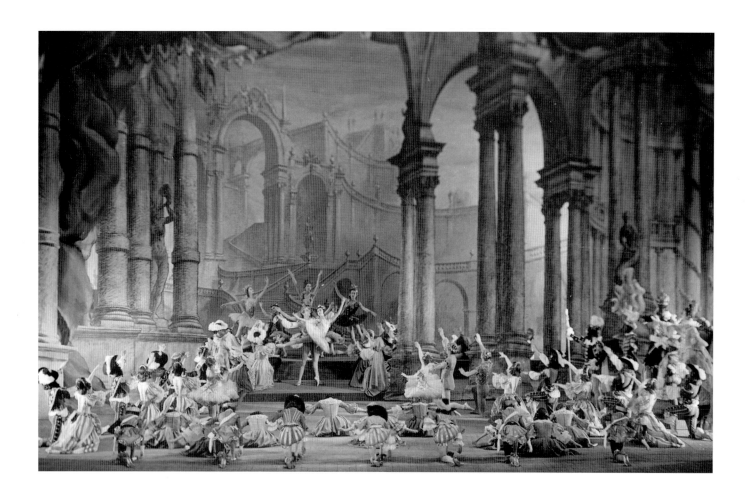

Fonteyn as Princess Aurora, Helpmann as Prince Florimund
with Artists of Sadler's Wells Ballet in Act III of *The Sleeping Beauty*, 1946
Design by Oliver Messel

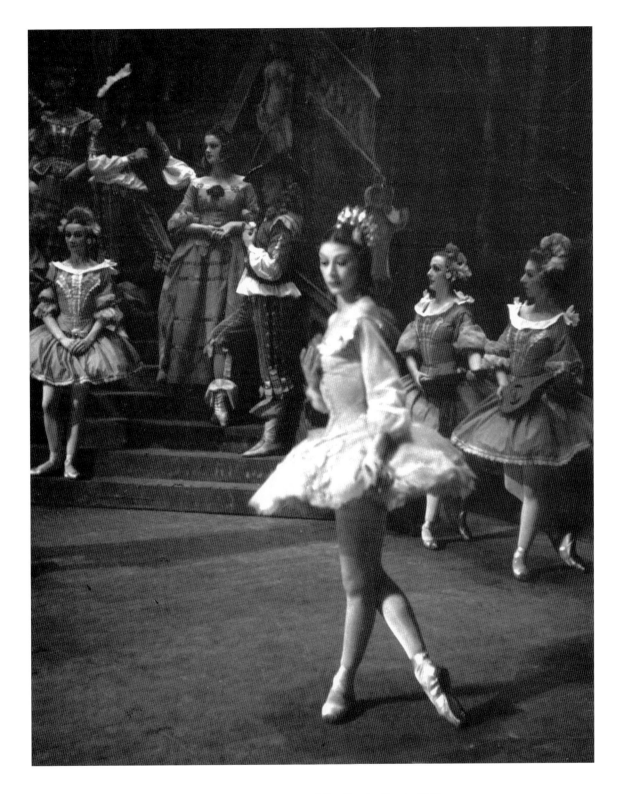

As Princess Aurora in Act I of *The Sleeping Beauty*, 1946

Frederick Ashton created *Symphonic Variations* in close collaboration with his friend, artist and designer Sophie Fedorovitch. There was a central role for Fonteyn and Ashton believed she 'gave the clue to the ballet'. He described how, 'hypnotically still, she represented a soul in a state of grace'. Fonteyn, with her partner Michael Somes, epitomised everything Ashton was trying to achieve as a choreographer. They became regular partners and Ashton went on to create many great ballets for them including *Daphnis and Chloë, Sylvia* and *Ondine*.

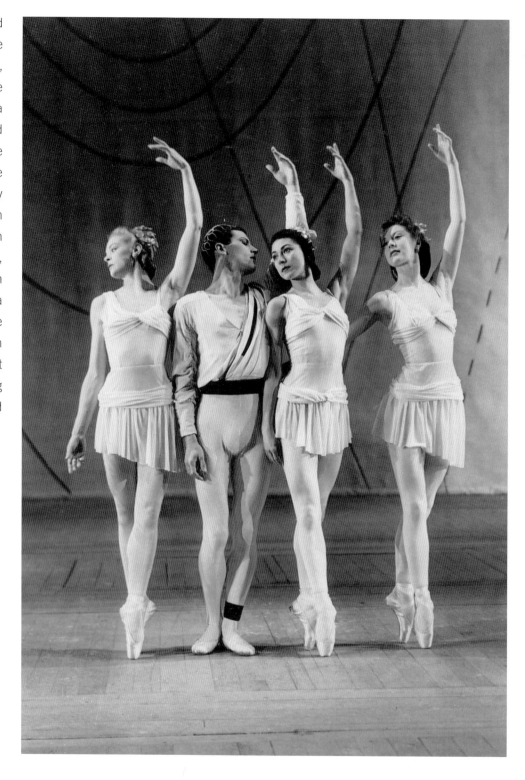

Pamela May, Michael Somes, Margot Fonteyn and Moira Shearer in *Symphonic Variations*, 1946

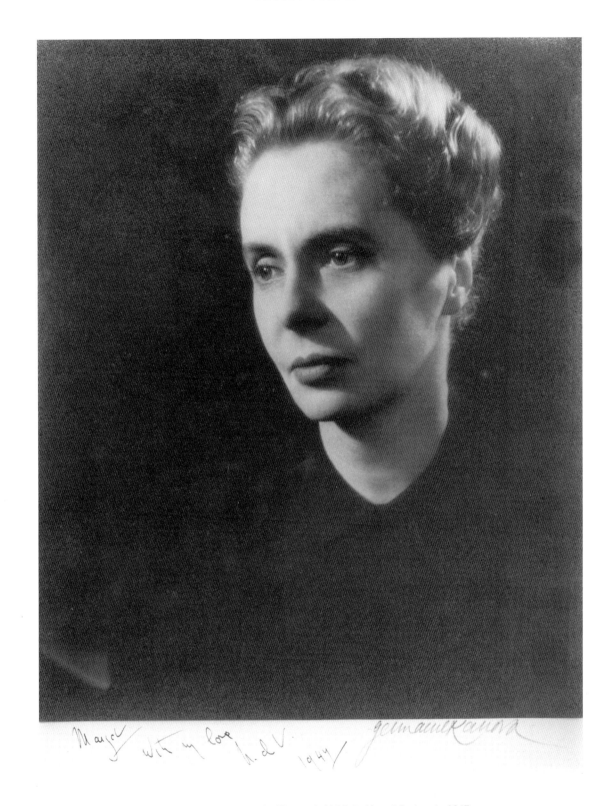

Signed photograph sent by Ninette de Valois to Margot Fonteyn in 1947

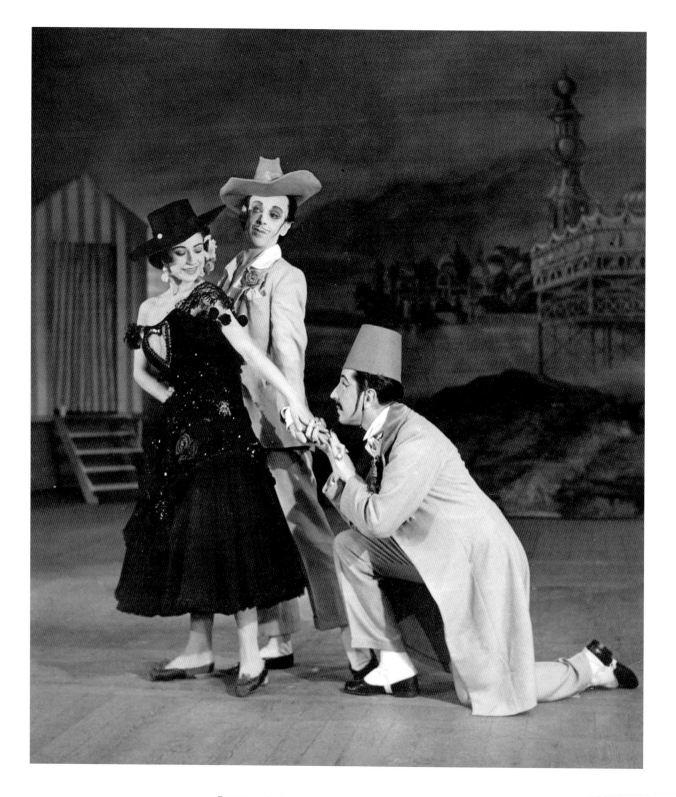

Fonteyn as La Bolero, Helpmann as Adelino Canberra
and Frederick Ashton as King Hihat of Agpar in *Les Sirènes*, 1946

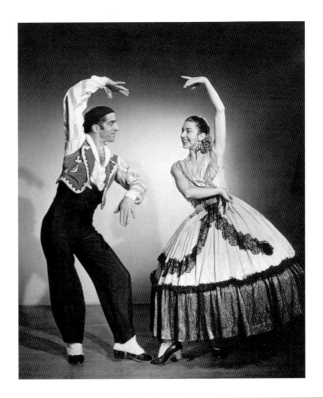

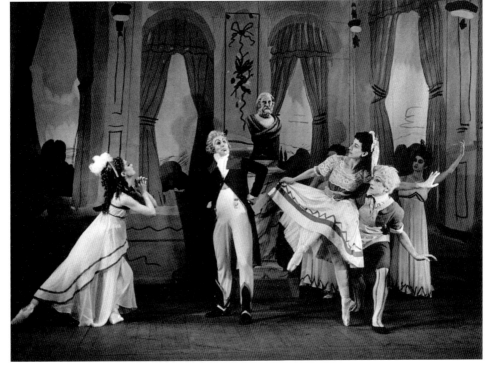

above: Léonide Massine as The Miller and Margot Fonteyn
as The Miller's Wife in *The Three-Cornered Hat*, 1947
below: Moira Shearer as The Aristocrat, John Hart as A Government Official, Margot Fonteyn
as Mam'zelle Angot and Alexander Grant as A Barber in *Mam'zelle Angot*, 1947

Frederick Ashton created *Scènes de ballet* as an abstract homage to Petipa's *Rose Adagio* with a pivotal role for Margot Fonteyn: 'I set out to display her with all the full richness of the classical ballet at my disposal.' He had equally clear views about her extremely elegant costume: 'Margot in yellow and her hair perfectly plain with a diamond choker and earrings.'

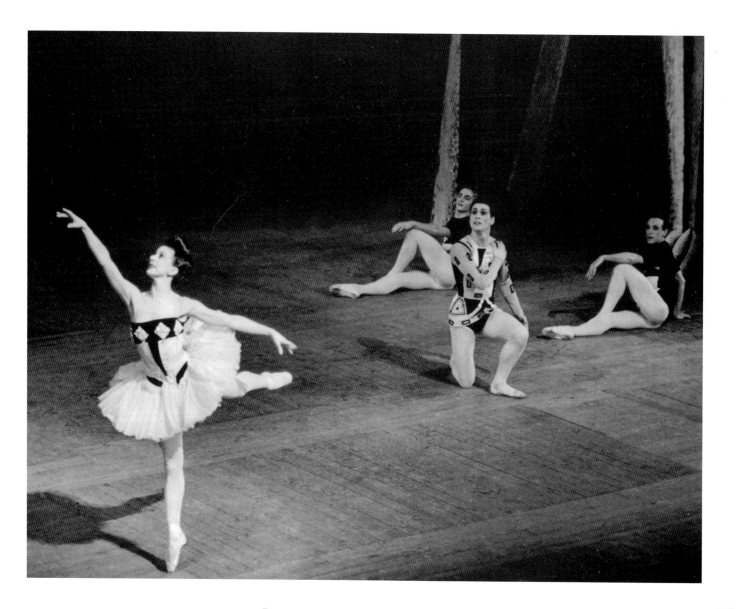

Fonteyn and Somes in *Scènes de ballet*, 1948

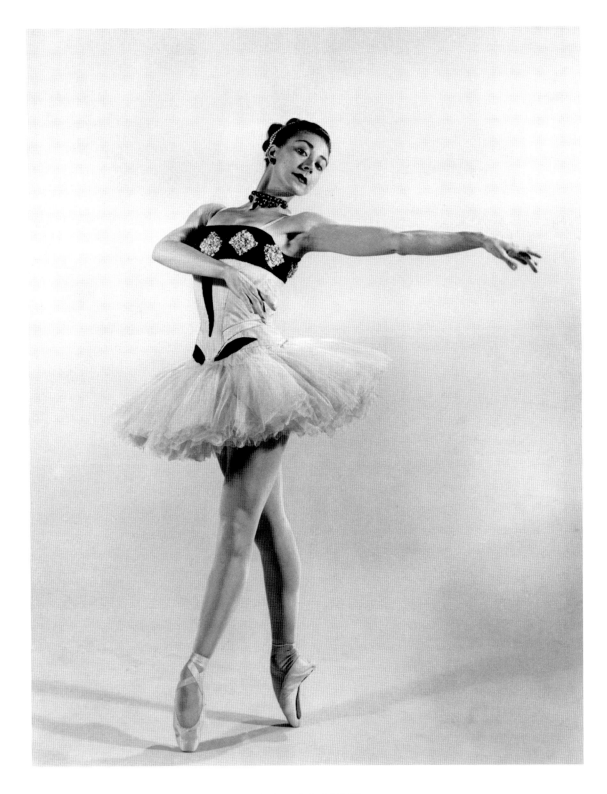

Scènes de ballet, 1948

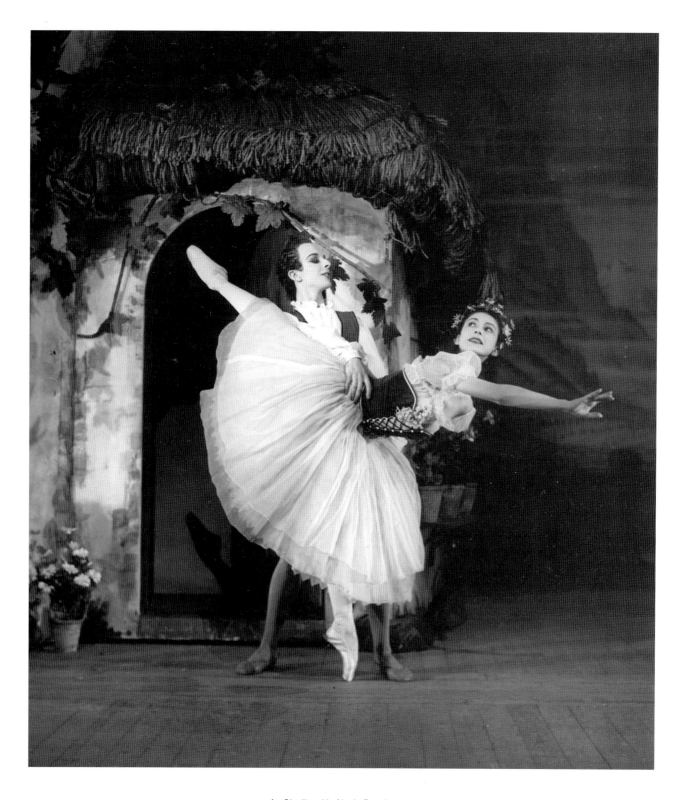

As Giselle with Alexis Rassine as
Count Albrecht in Act I of *Giselle*, 1946

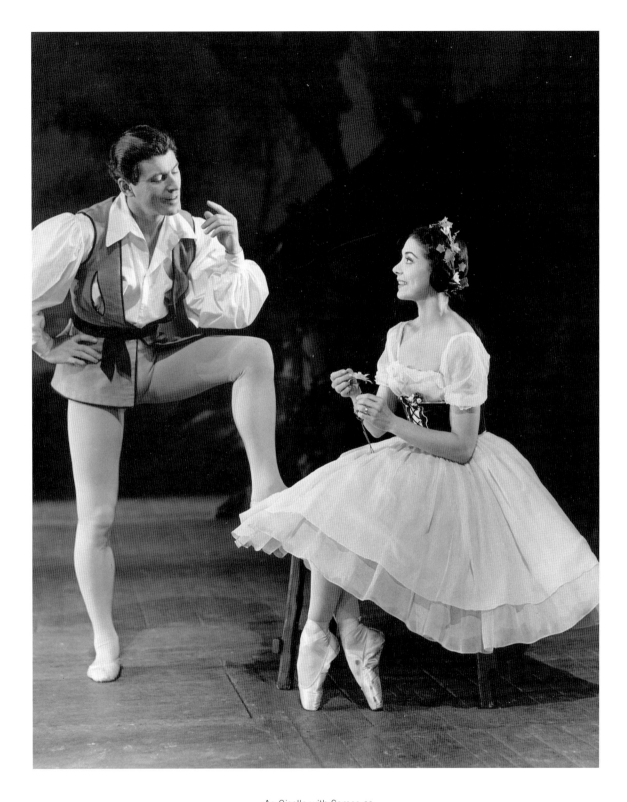

As Giselle with Somes as
Count Albrecht in Act I of *Giselle*

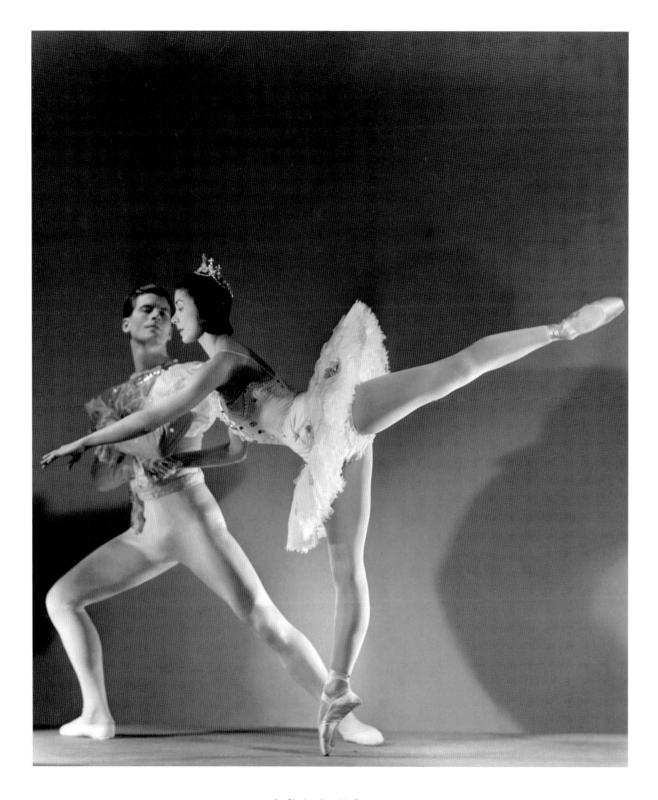

As Cinderella with Somes
as The Prince in *Cinderella*, 1949

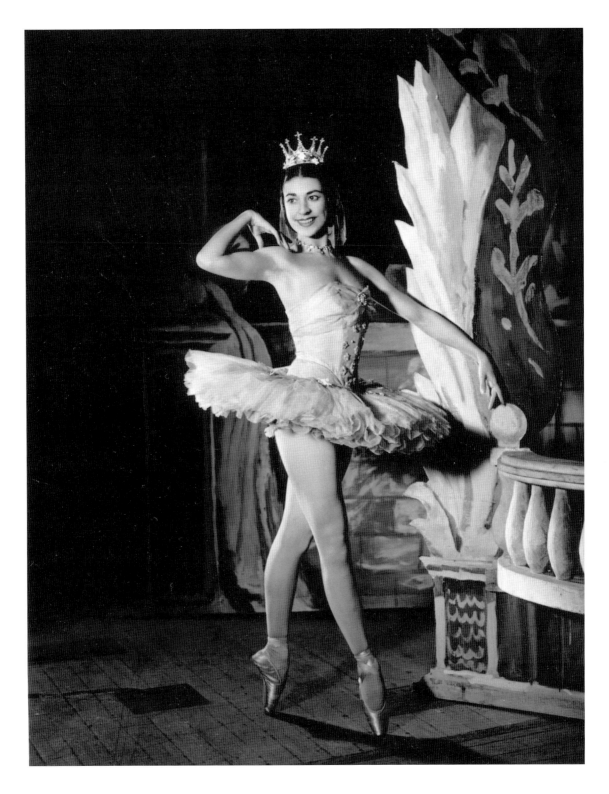

Cinderella, 1949

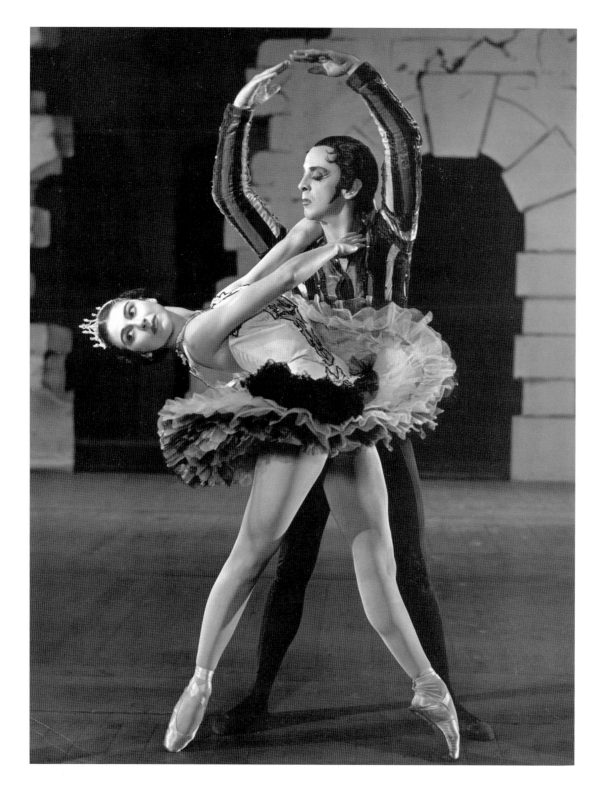

Fonteyn as La Morte Amoureuse and Helpmann
as Don Juan in *Don Juan*, 1948

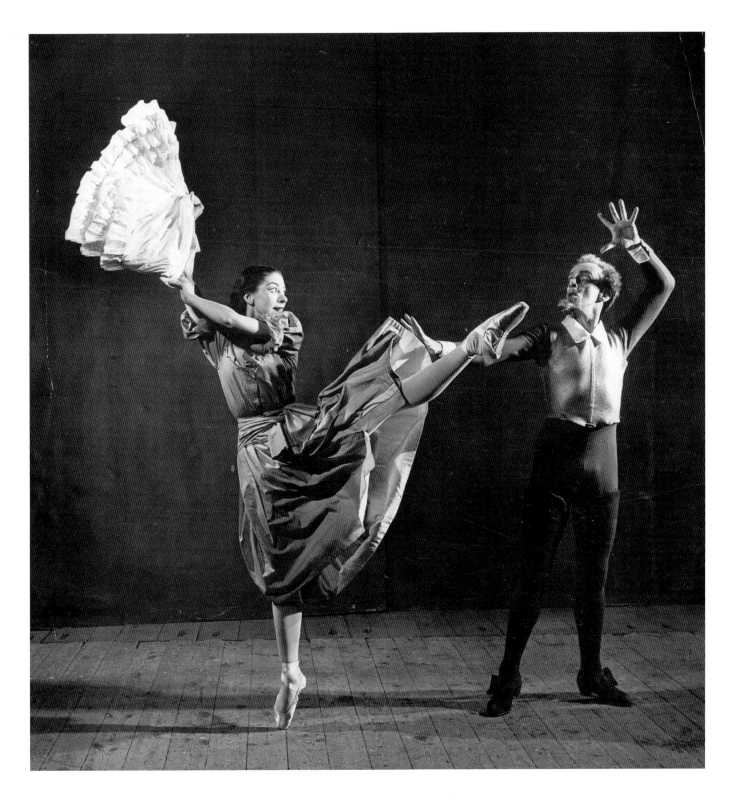

As The Lady Dulcinea (Aldonza Lorenzo) with Helpmann
as Don Quixote in *Don Quixote*, choreographed by Ninette de Valois in 1950

Frederick Ashton created the role of Chloë in *Daphnis and Chloë* for Margot Fonteyn in 1951. Nadia Nerina has said that 'Fred really found her personality in that role – the elegance, the correctness – that really was Margot.' The part explored her purity, her vulnerability and pathos, as well as the radiant simplicity of her dancing.

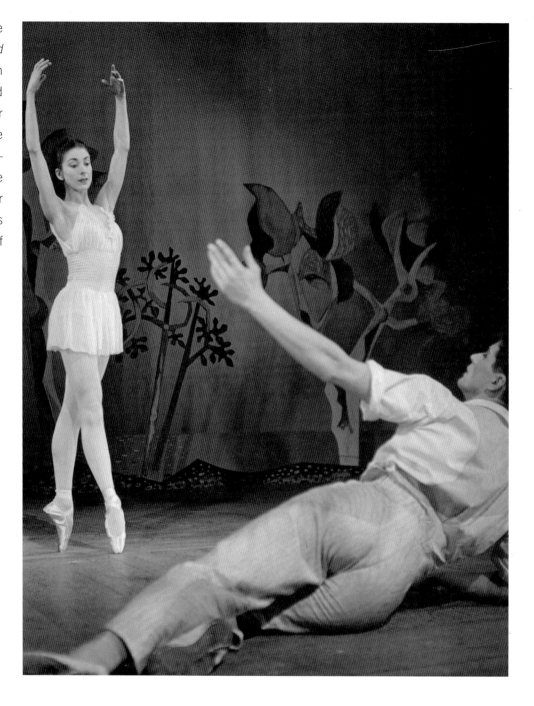

Fonteyn as Chloë and Somes as Daphnis
in *Daphnis and Chloë*, 1951

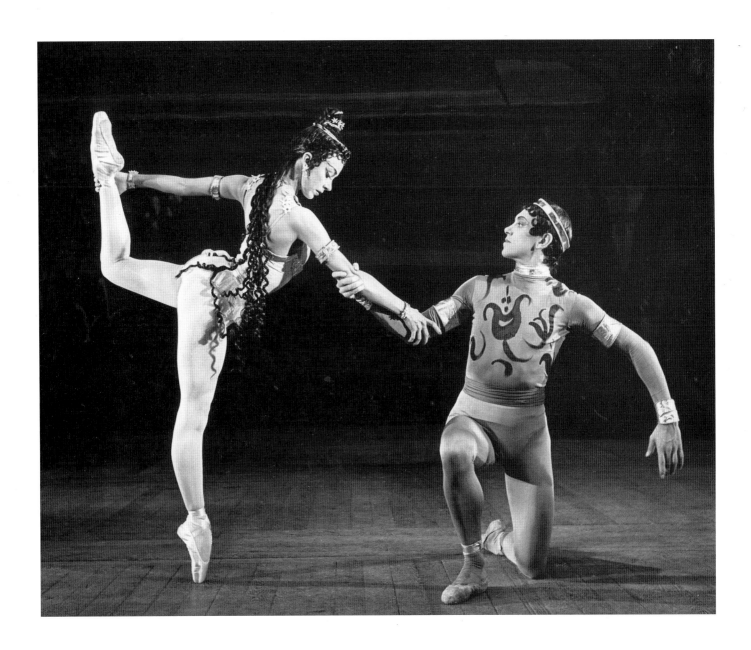

Fonteyn as the female Tiresias with John Field
as Her Lover in *Tiresias*, 1951

In 1952 Frederick Ashton created the three-act ballet *Sylvia* for Margot Fonteyn. The role exploited her extraordinary range as a dancer. Fellow dancer Annette Page has said that '*Sylvia* was the best thing Margot ever danced, she was glorious in it. Her technique in the mid-1950s was phenomenal – her Black Swan left us breathless.'

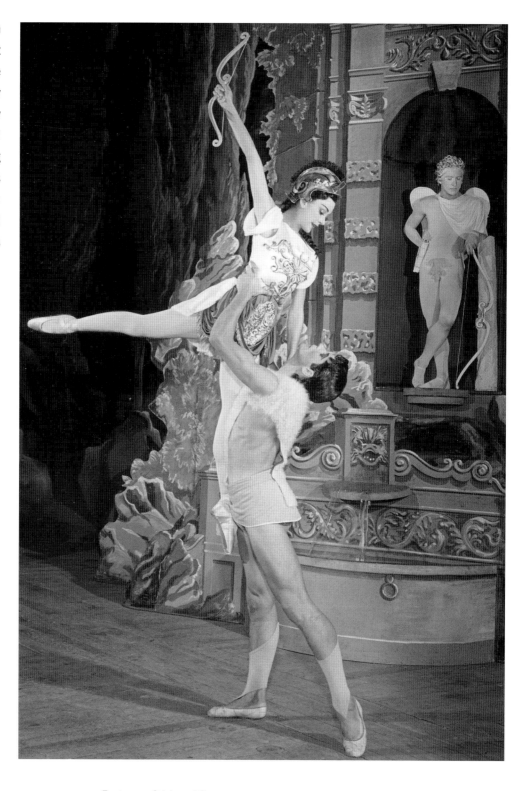

Fonteyn as Sylvia and Somes
as Aminta in Act I of *Sylvia*, 1952

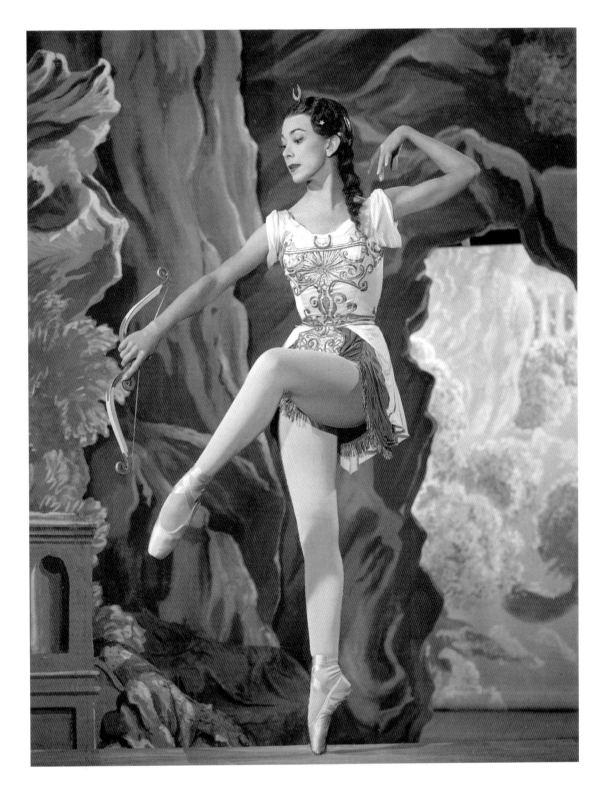

Sylvia Act I, 1952

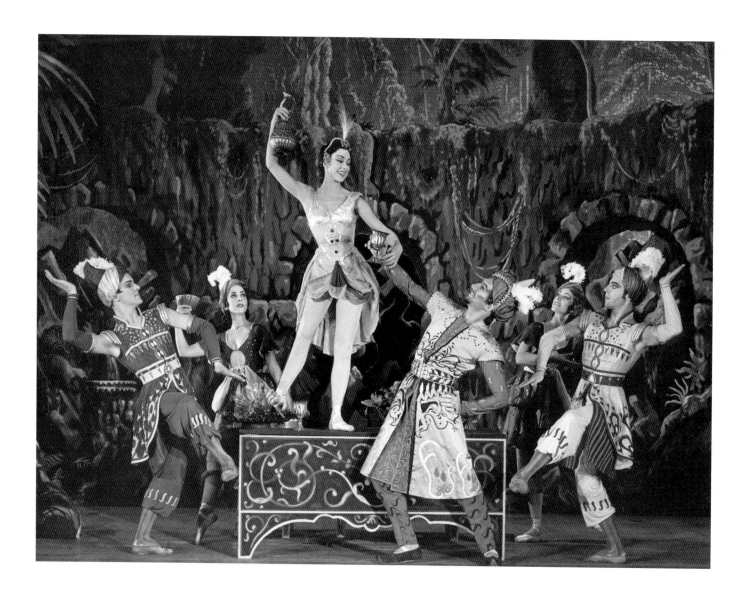

Peter Clegg as A Slave, Fonteyn as Sylvia, John Hart as Orion
and Brian Shaw as A Slave in Act II of *Sylvia*, 1952

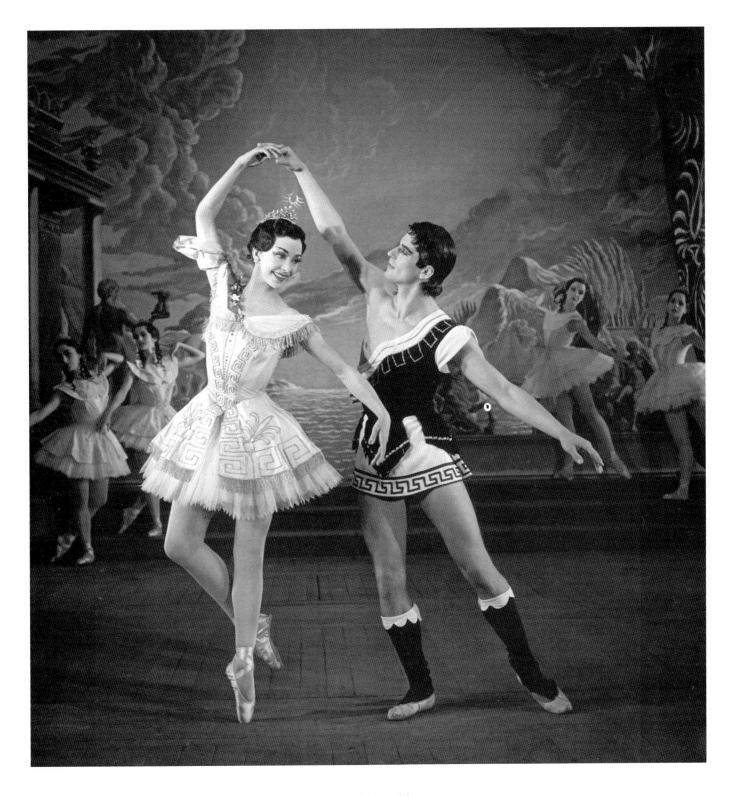

Fonteyn as Sylvia and Somes
as Aminta in Act III of *Sylvia*, 1952

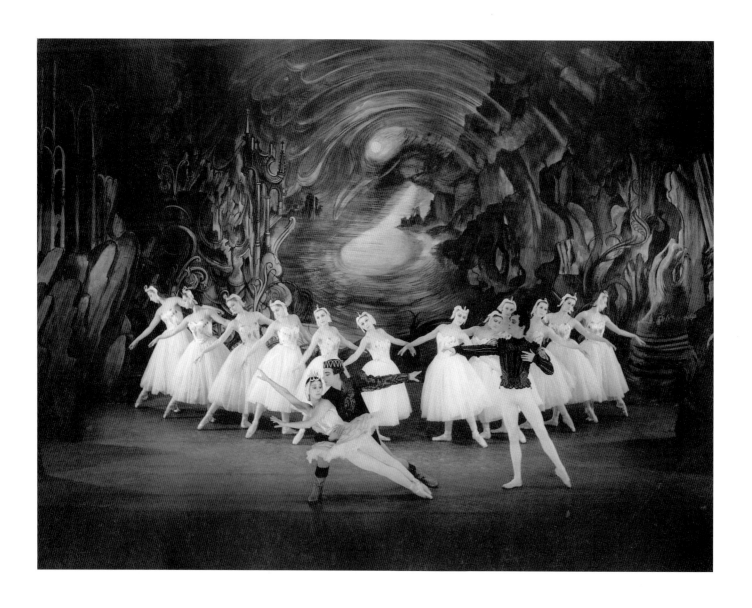

Fonteyn as Odette, Leslie Edwards as Benno and Helpmann (right)
as Prince Siegfried in *Le Lac des cygnes*, 1946

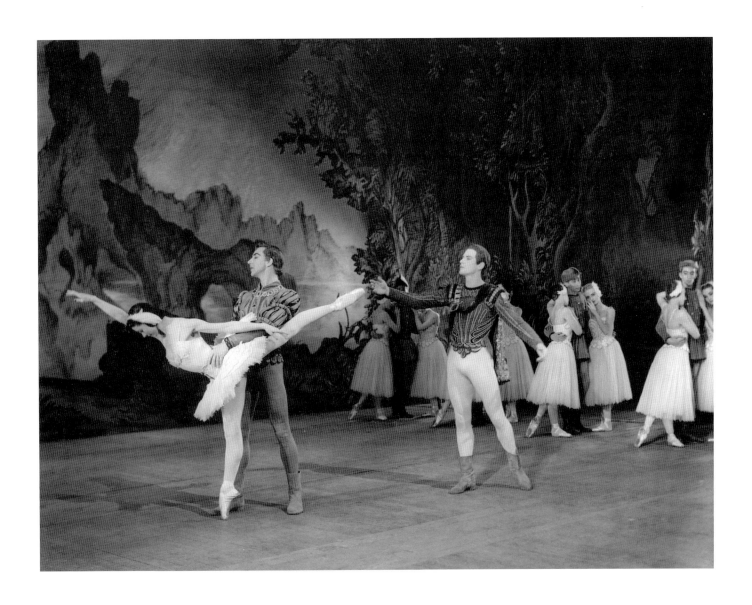

Fonteyn as Odette, Edwards as Benno and Somes (right)
as Prince Siegfried in *Le Lac des cygnes*, 1953

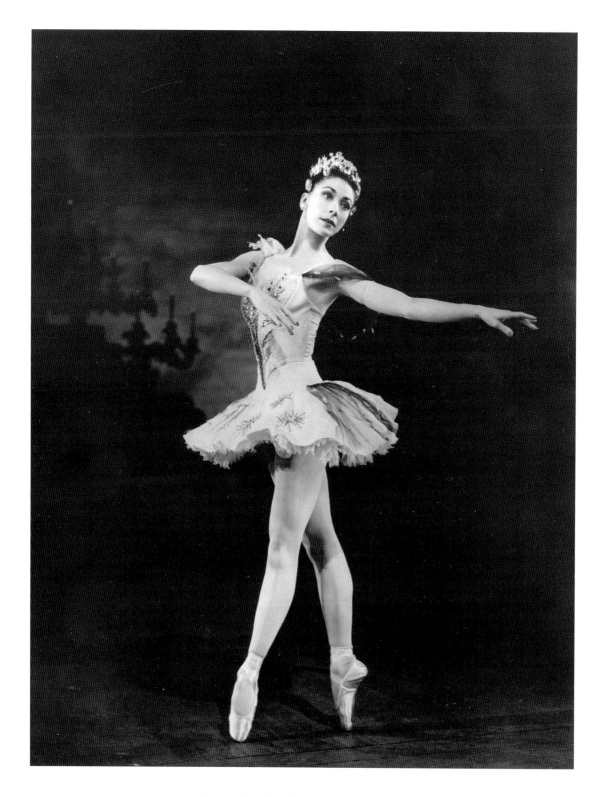

As Queen of the Air in *Homage to the Queen*, 1953

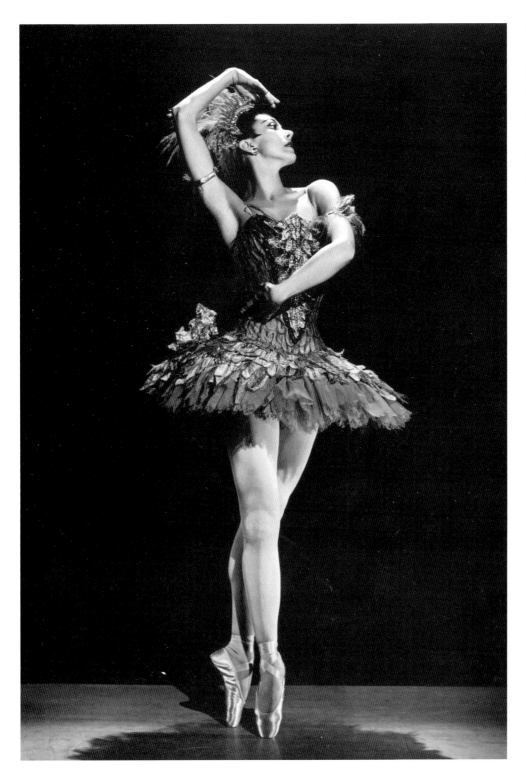

Fonteyn was taught the role of The Firebird by the great Russian ballerina Tamara Karsavina, who had created the role for the choreographer Michel Fokine with Serge Diaghilev's *Ballets Russes* Company in Paris on 25 June 1910.

The Firebird, 1954

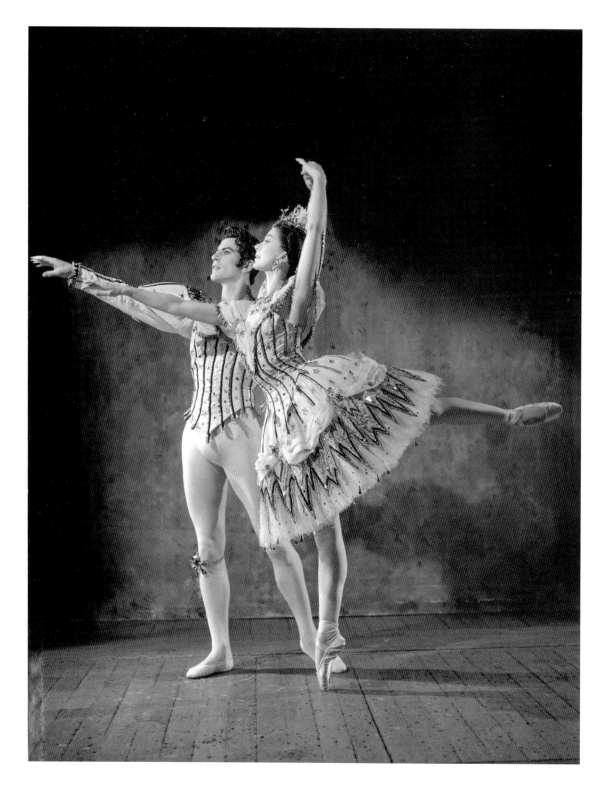

Fonteyn and Somes in *Birthday Offering*, 1956

REHEARSALS, TAKING NEW YORK BY STORM, MARRIAGE

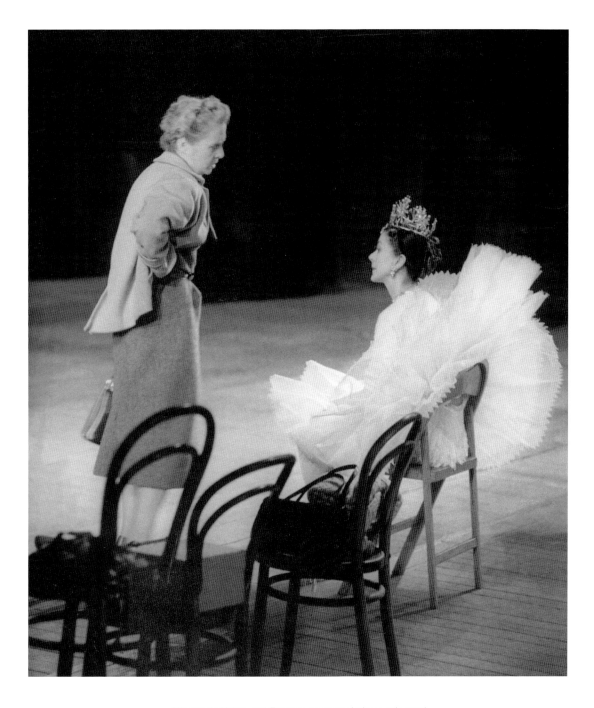

Ninette de Valois and Fonteyn on stage during a rehearsal
for *Birthday Offering*, created by Frederick Ashton as a tribute to de Valois
on the occasion of the Company's 25th birthday, 1956

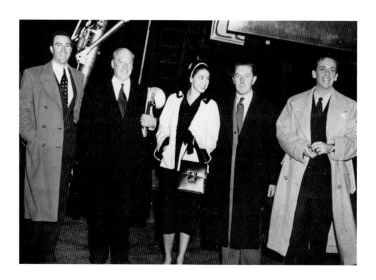

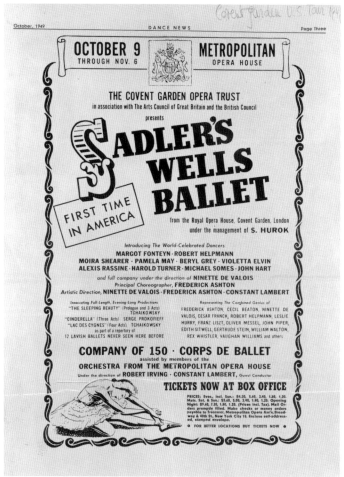

Sadler's Wells Ballet's first tour to New York, October 1949
left to right: Leslie Edwards, David Webster, General Administrator of the Royal Opera House,
Margot Fonteyn, Frederick Ashton and Robert Helpmann

Relaxing on the US tour
above, in the foreground: Violetta Elvin, Pamela May, Margot Fonteyn and Beryl Grey
below: Fonteyn's mother, known as BQ (Black Queen), Margot Fonteyn, Pamela May and Leslie Edwards

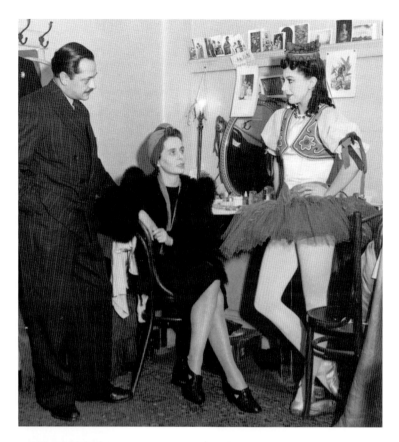

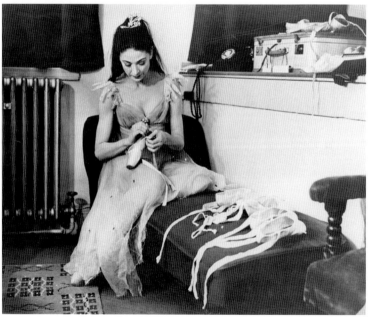

above: Margot Fonteyn, in costume for *Coppélia*, with Ninette de Valois and Harold Arneil, manager and stage director, in her dressing room at the Royal Opera House
below: in costume for *Ondine*, sewing ribbons on her ballet shoes

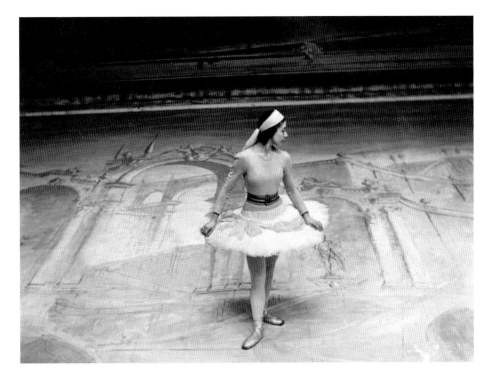

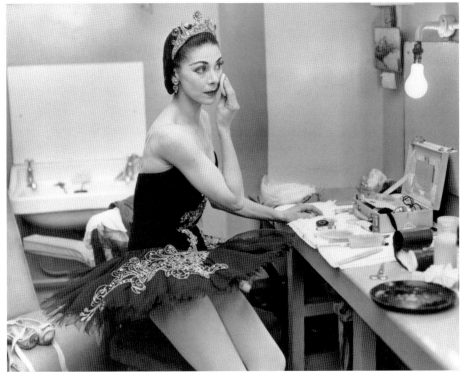

above: standing on the half-painted backdrop for Act III
of *The Sleeping Beauty*, on stage at the Royal Opera House
below: in costume for Odile (the Black Swan)
in *Swan Lake* in her dressing room

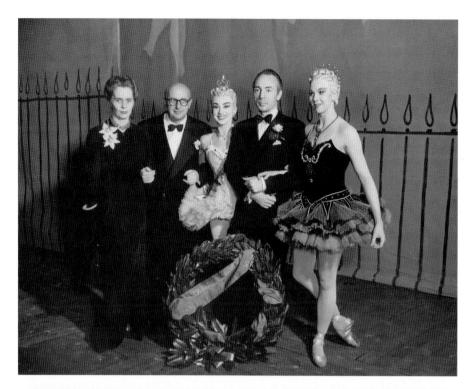

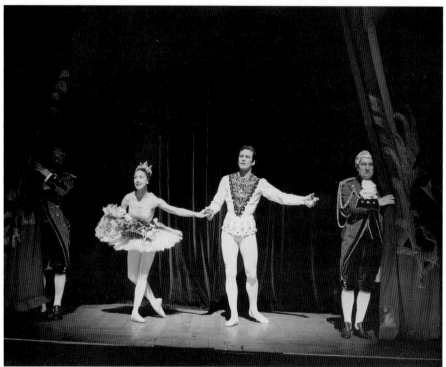

above, left to right: Ninette de Valois, designer Eugene Berman, Margot Fonteyn,
George Balanchine and Beryl Grey after the first performance of *Ballet Imperial* by Sadler's Wells Ballet.
This was the first Balanchine work performed by the Company.
below: Fonteyn and Somes taking a curtain call for *Cinderella* at the Royal Opera House

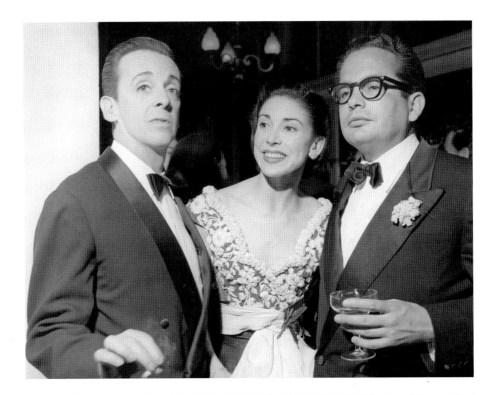

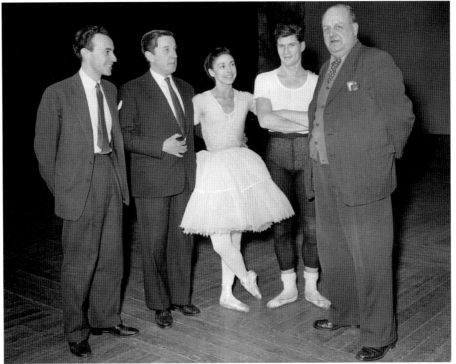

above: Helpmann, Fonteyn and Tito Arias, Fonteyn's husband
below (centre): Ashton, Fonteyn and Somes
during a rehearsal for *Birthday Offering*, 1956

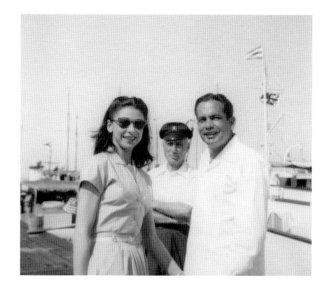

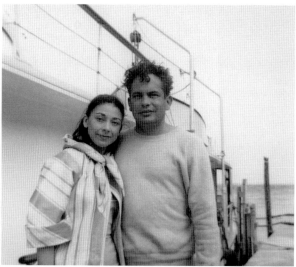

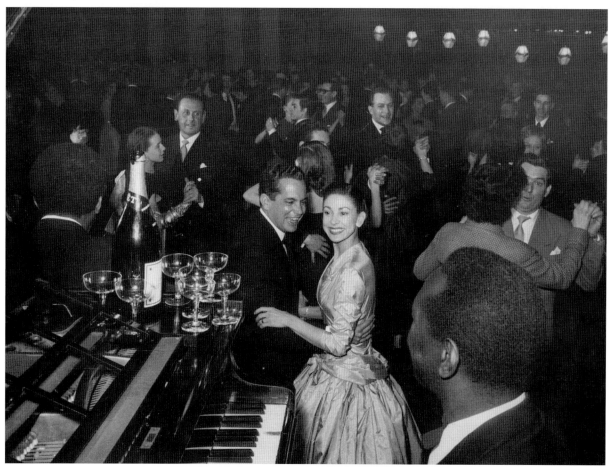

With her husband Tito
above: relaxing on holiday, *below:* at the party on stage at the Royal Opera House
to celebrate their marriage in 1955

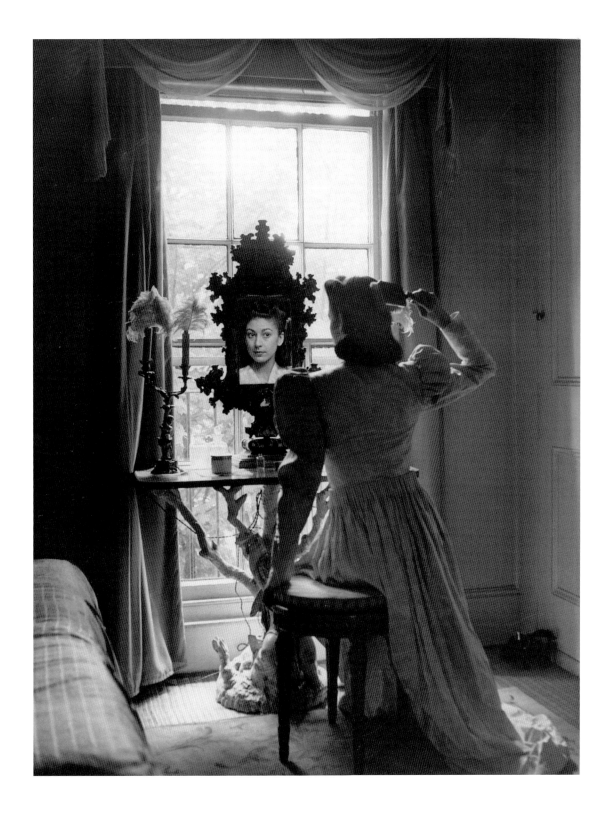

THE ROYAL BALLET – PRIMA BALLERINA ASSOLUTA

Margot Fonteyn's great love of the sea was celebrated by Ashton when he created the role of the water sprite, the Ondine, in *Ondine* for her in 1958. In the early 1960s Fonteyn was beginning to think about retiring when Rudolf Nureyev leapt onto the ballet scene. She later described how 'Rudolf Nureyev brought me a second career, like an Indian summer.' In 1979, HRH

The Princess Margaret, President of The Royal Ballet, announced that the Board and the General Administrator of the Royal Opera House had decided to award Margot Fonteyn the title *Prima Ballerina Assoluta*, the first and so far only time the title has been awarded in this country.

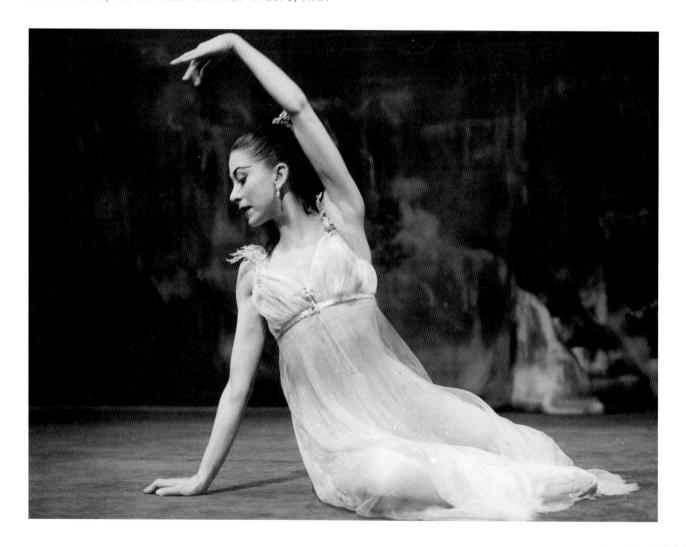

Ondine, 1958

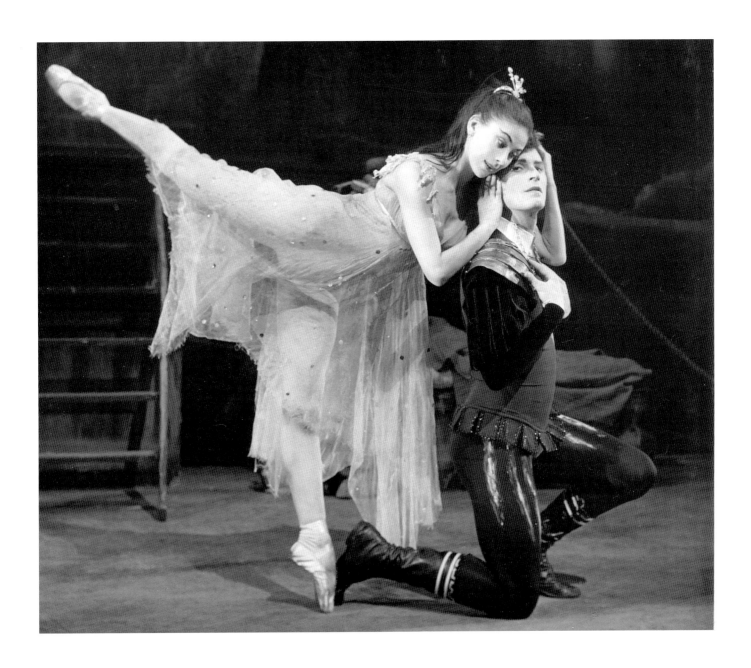

As Ondine with Somes as Palemon in *Ondine*, 1958

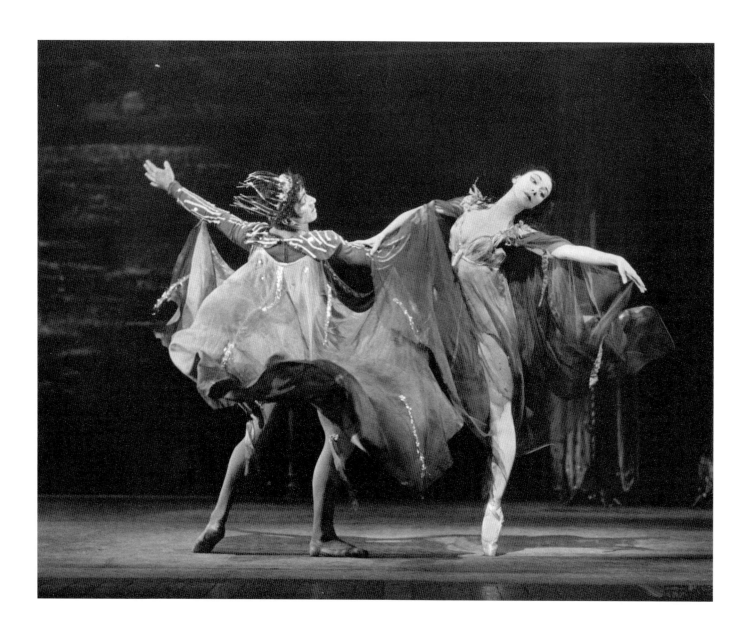

Alexander Grant as Tirrenio and Fonteyn as Ondine in *Ondine*, 1958

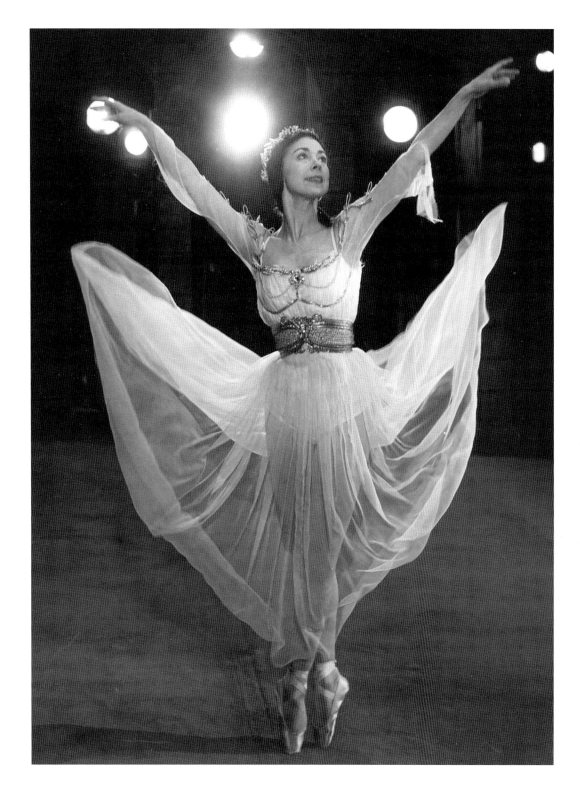

In *Raymonda, Scène d'amour*, choreographed by Frederick Ashton in 1960

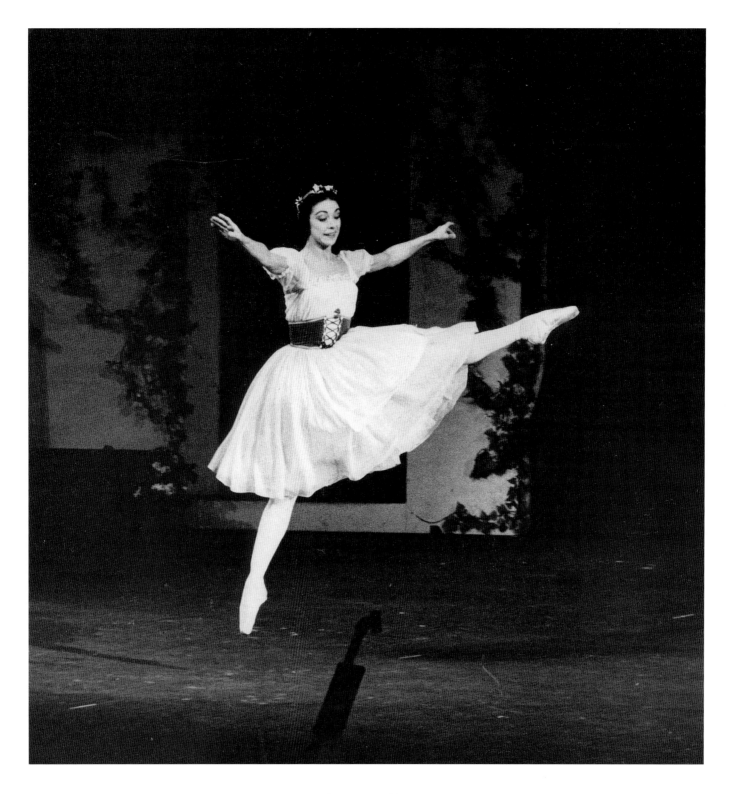

Giselle Act I, 1967

Frederick Ashton, two weeks before their first appearance together at the Royal Opera House on 21 February 1962, said with great prescience, 'It could be that the appearance of Margot Fonteyn and Rudolf Nureyev in *Giselle* will cause as big a stir as the performances of Pavlova and Nijinsky in the same ballet.'

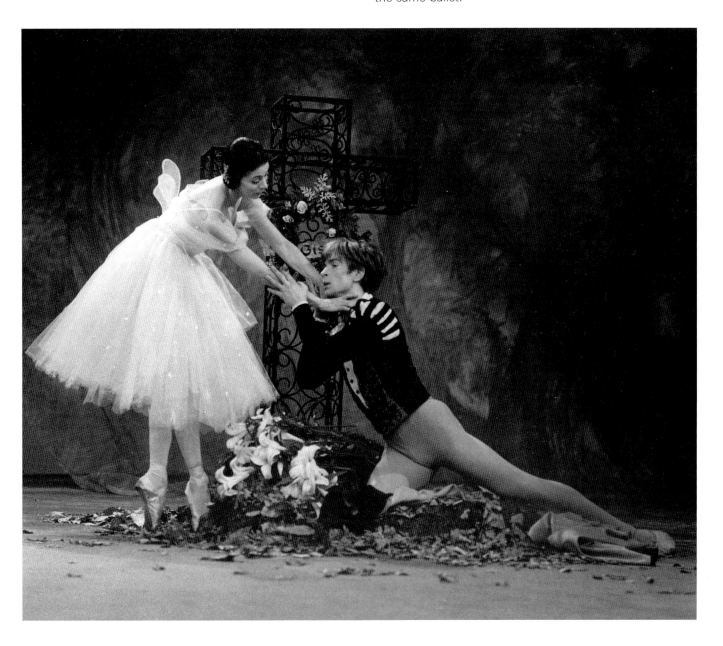

With Rudolf Nureyev as Count Albrecht in Act II of *Giselle,* 1962

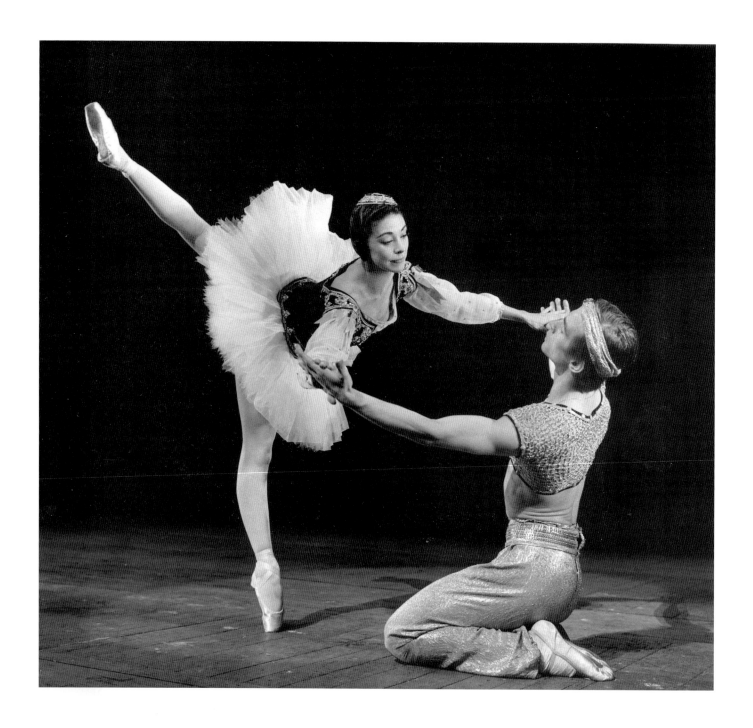

Fonteyn and Nureyev in *Le Corsaire pas de deux*
They first danced this *pas de deux* at the Royal Opera House on 3 November 1962.
It caused a sensation and they were often to dance it together.

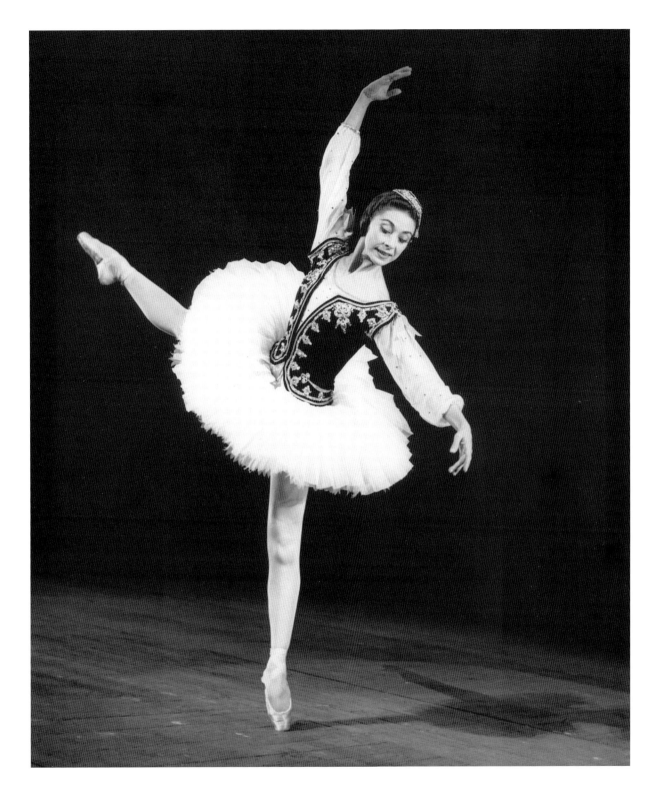

Le Corsaire pas de deux, 1962

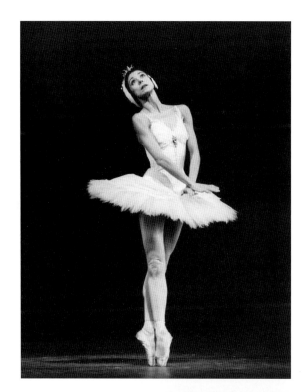
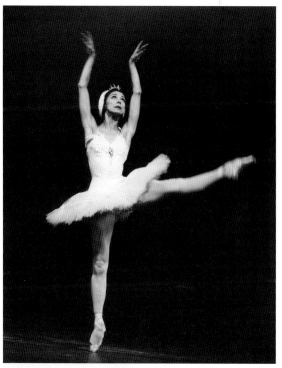
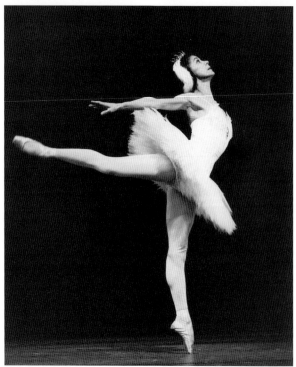

As Odette in *Swan Lake*, 1963

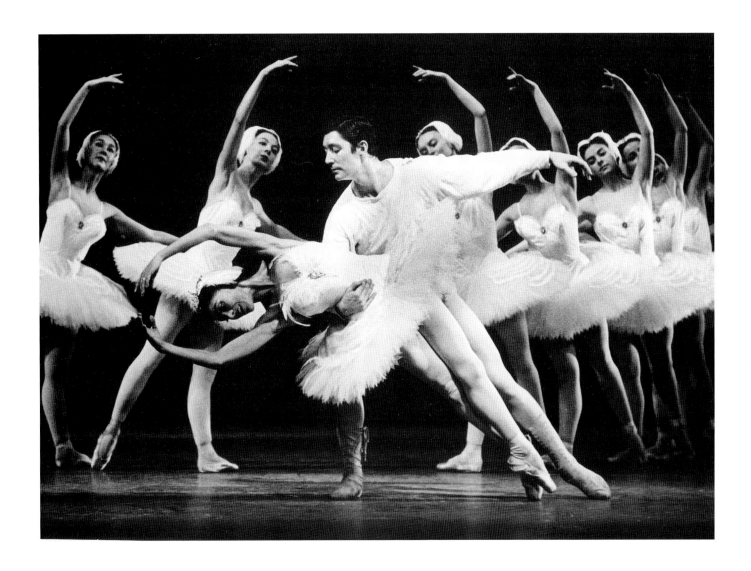

Fonteyn as Odette with David Blair as Prince Siegfried in rehearsal for *Swan Lake*, 1963
David Blair joined Sadler's Wells Ballet in November 1946. He partnered Fonteyn in the
new production of Swan Lake, produced by Robert Helpmann in 1963.

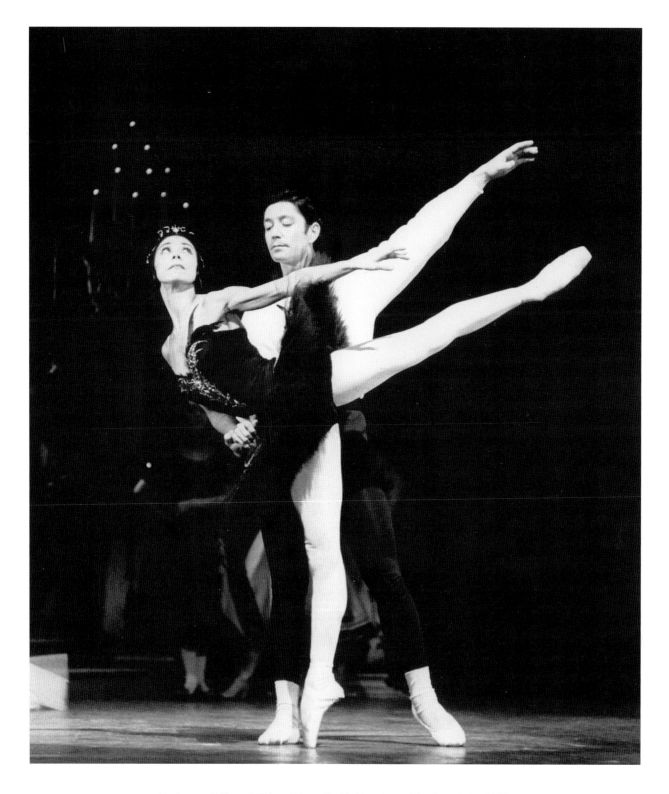

Fonteyn as Odile and Blair as Prince Siegfried in rehearsal for *Swan Lake*, 1963

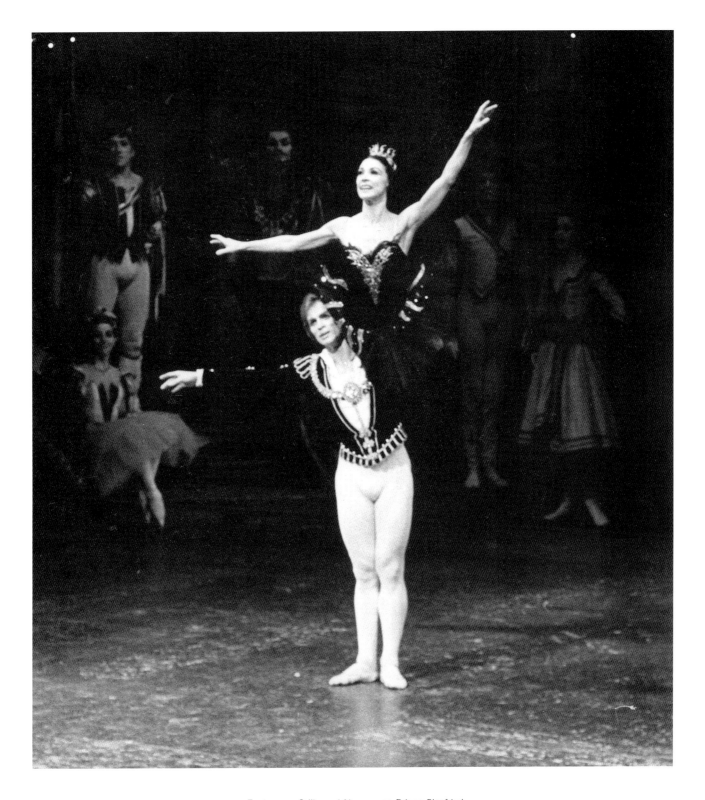

Fonteyn as Odile and Nureyev as Prince Siegfried
in *Swan Lake*, Metropolitan Opera House,
The Royal Ballet tour to New York, April 1967

Fonteyn and Nureyev's great partnership was celebrated by Frederick Ashton when he created the highly romantic ballet *Marguerite and Armand* for them. The ballet is based on the Alexandre Dumas *fils* story of *La Dame aux camélias*. No-one else danced it in their lifetimes.

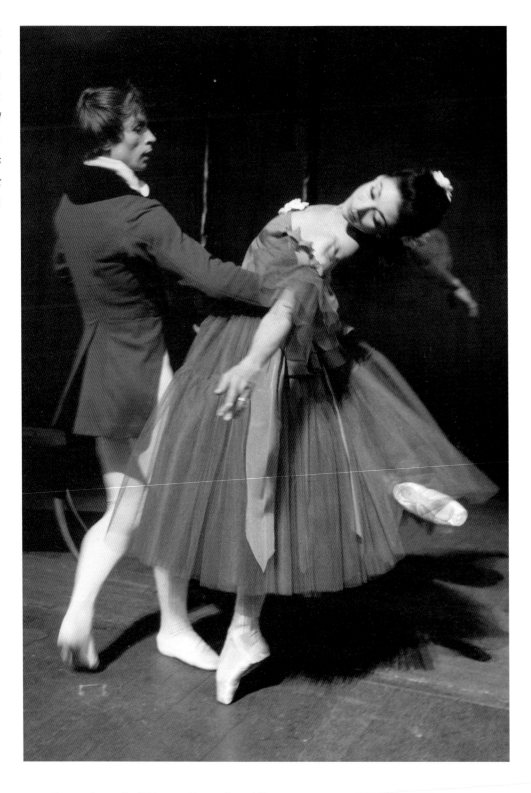

above and opposite: Fonteyn as Marguerite and Nureyev as Armand in *Marguerite and Armand*, 1963

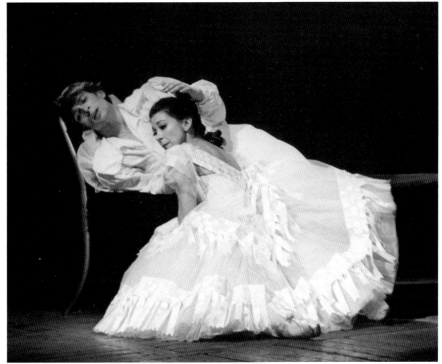

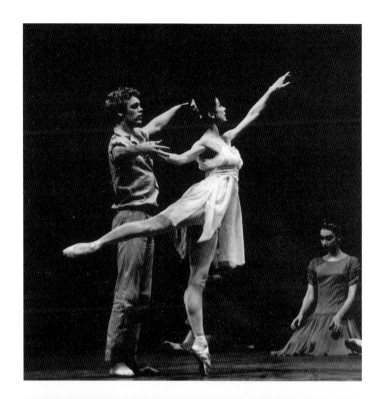

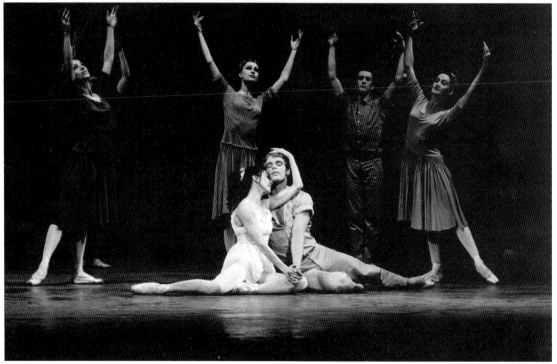

Fonteyn as Chloë and Christopher Gable
as Daphnis in *Daphnis and Chloë*, 1964

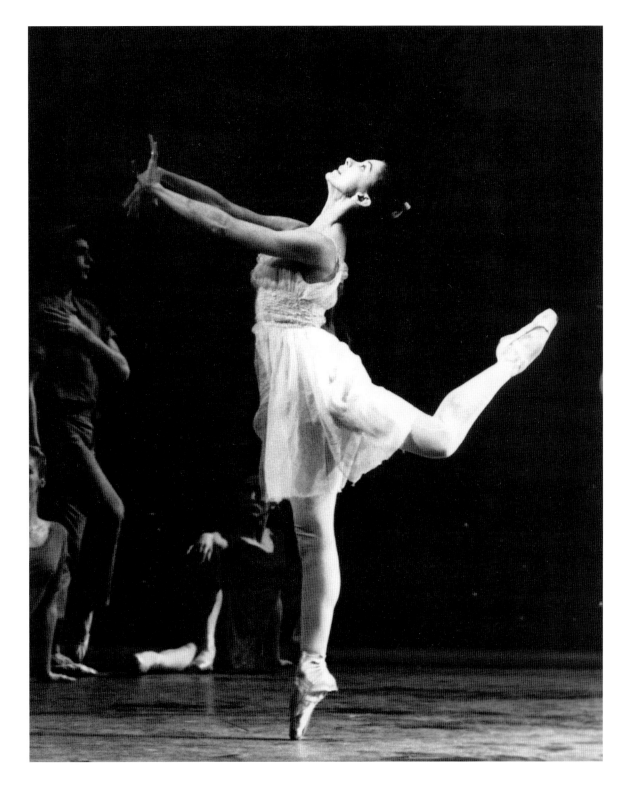

As Chloë in *Daphnis and Chloë*, 1964

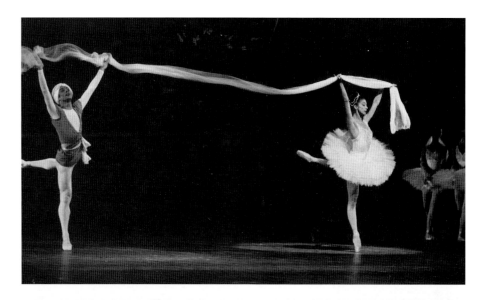

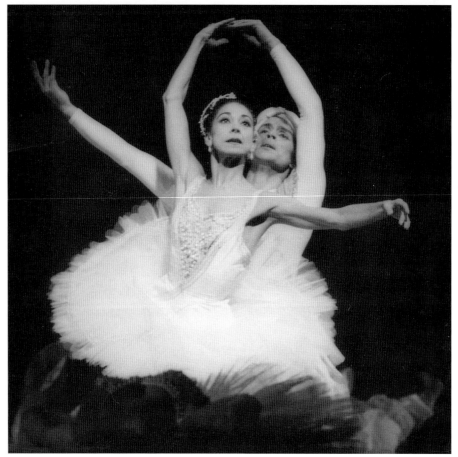

Fonteyn as Nikiya and Nureyev as Solor in *La Bayadère*, 1963
Nureyev staged the Kingdom of the Shades scene from *La Bayadère* for The Royal Ballet,
the first time any of the ballet had been seen in the West.

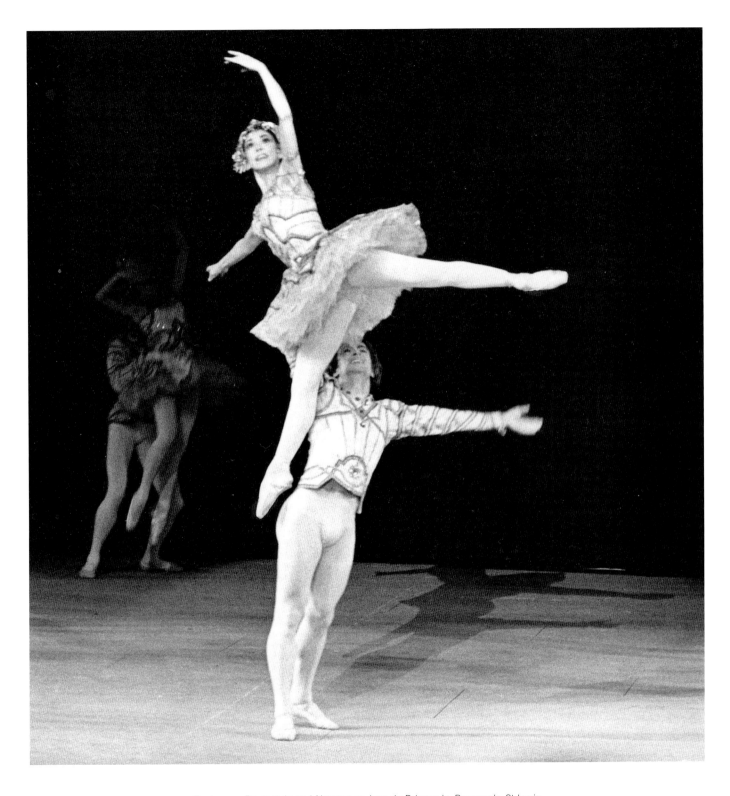

Fonteyn as Raymonda and Nureyev as Jean de Brienne in *Raymonda*, St Louis,
The Royal Ballet American tour, July 1969

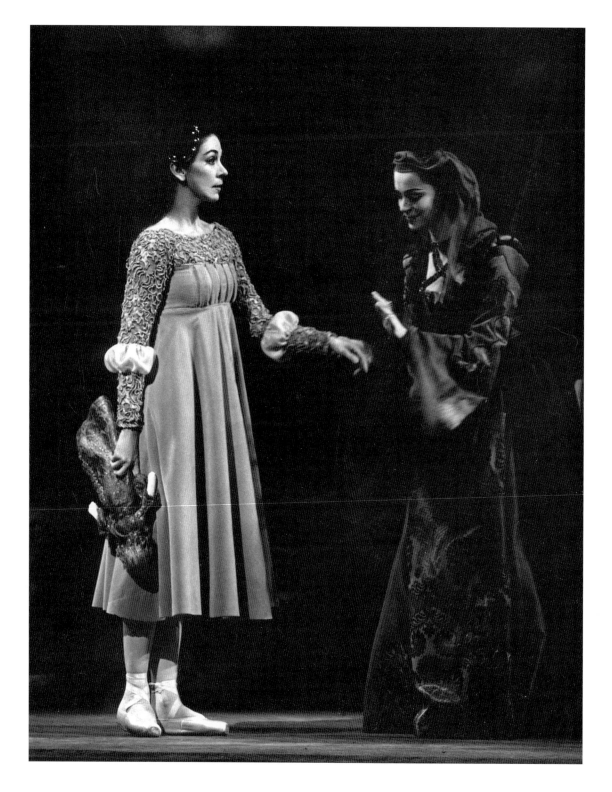

Fonteyn as Juliet with Julia Farron
as Lady Capulet in Act I of *Romeo and Juliet*,
choreographed by Kenneth MacMillan, 1965

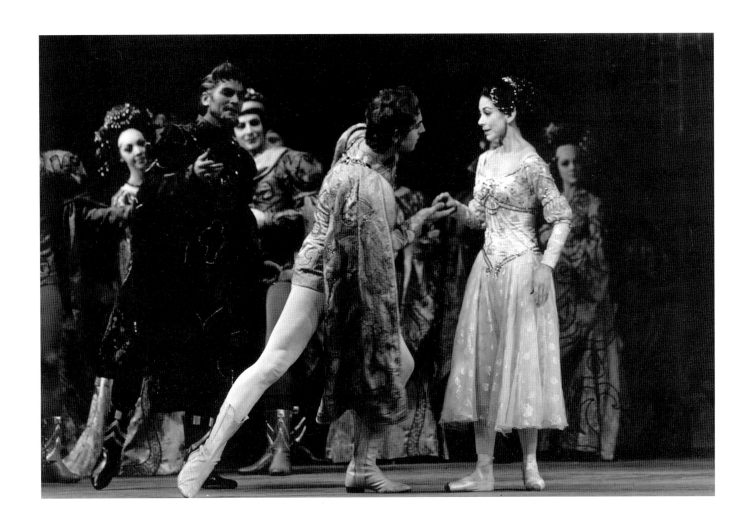

Derek Rencher as Paris and Fonteyn
as Juliet in Act I of *Romeo and Juliet*, 1965

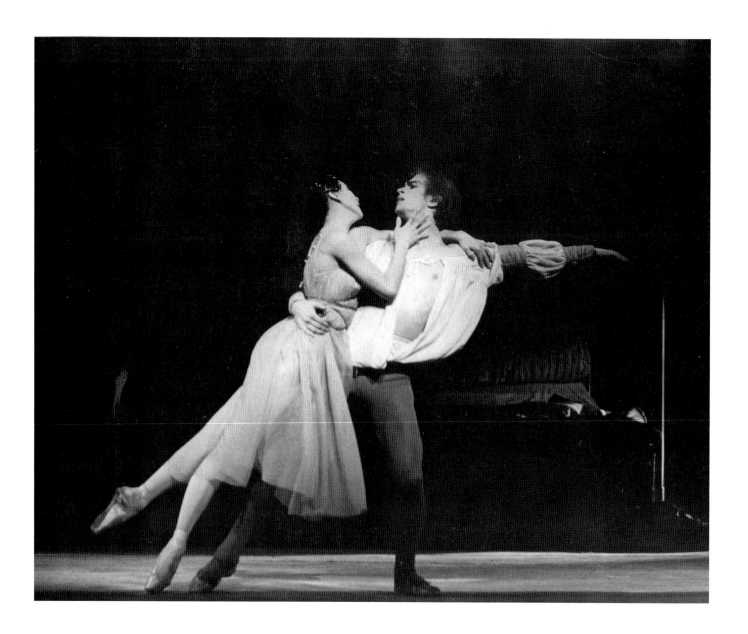

above and opposite: Fonteyn as Juliet and Nureyev
as Romeo in *Romeo and Juliet,* 1965

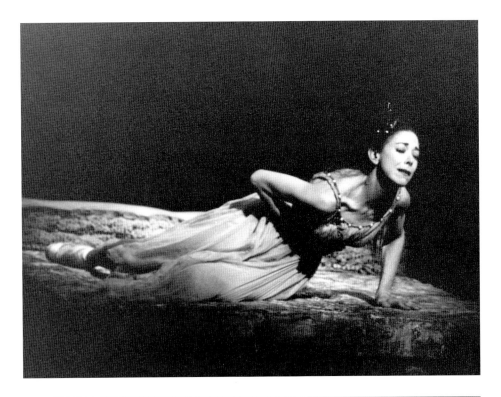

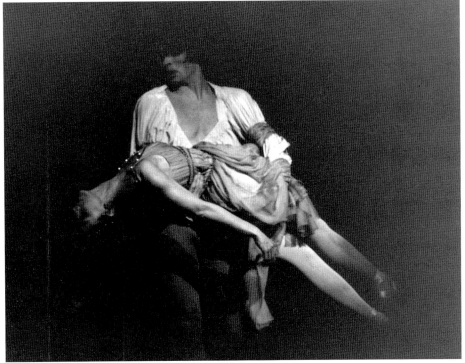

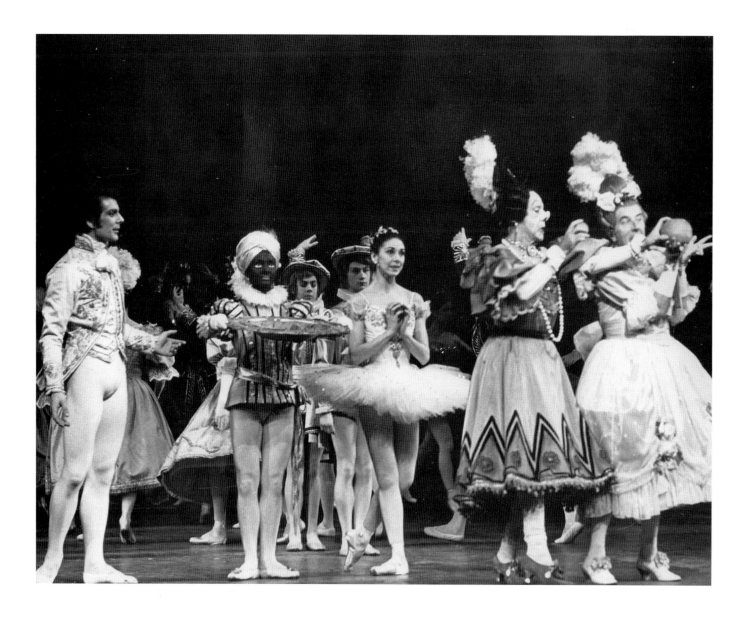

Donald Macleary as The Prince, Margot Fonteyn as Cinderella, Robert Helpmann
and Frederick Ashton as the Stepsisters in *Cinderella*, 1965

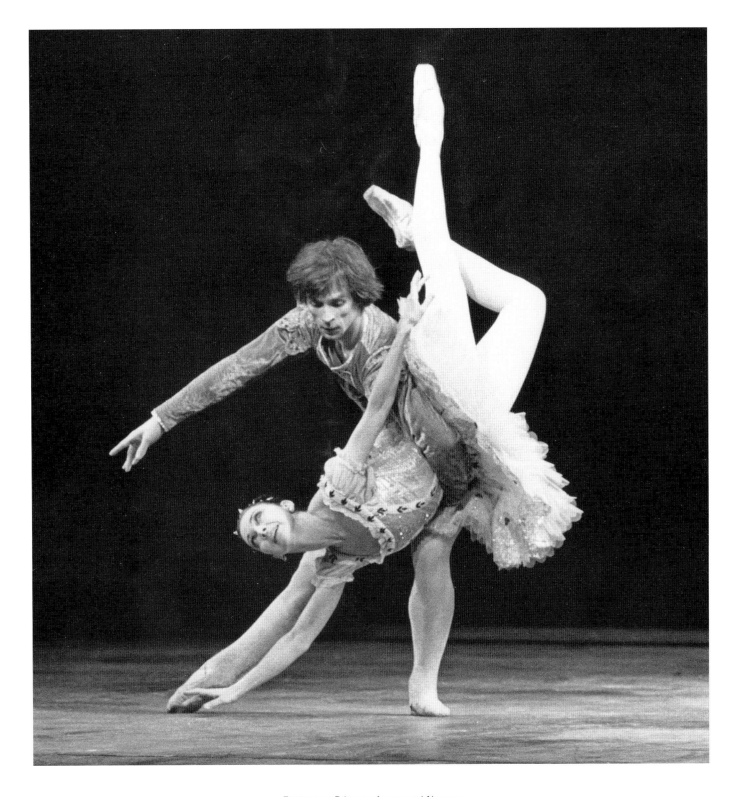

Fonteyn as Princess Aurora and Nureyev
as Prince Florimund in *The Sleeping Beauty*, 1972

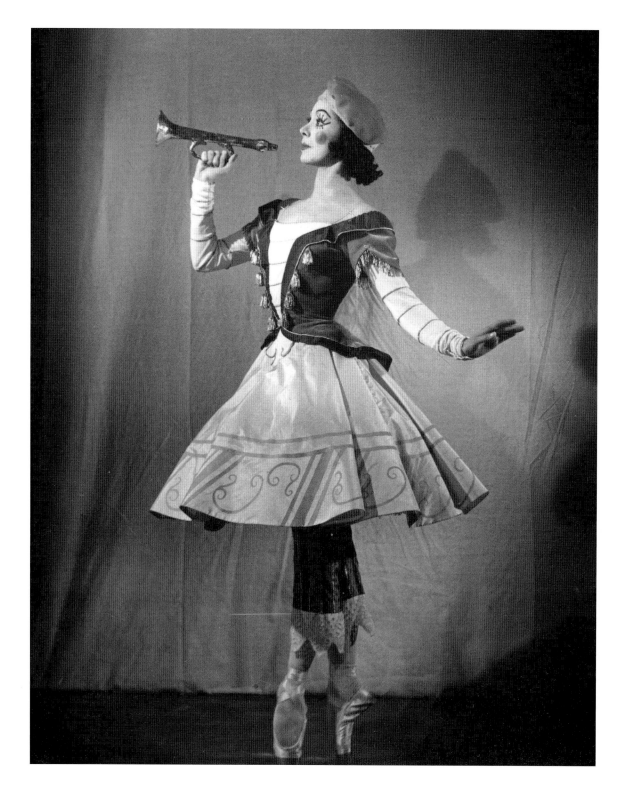

As The Ballerina in *Petrushka*, 1957

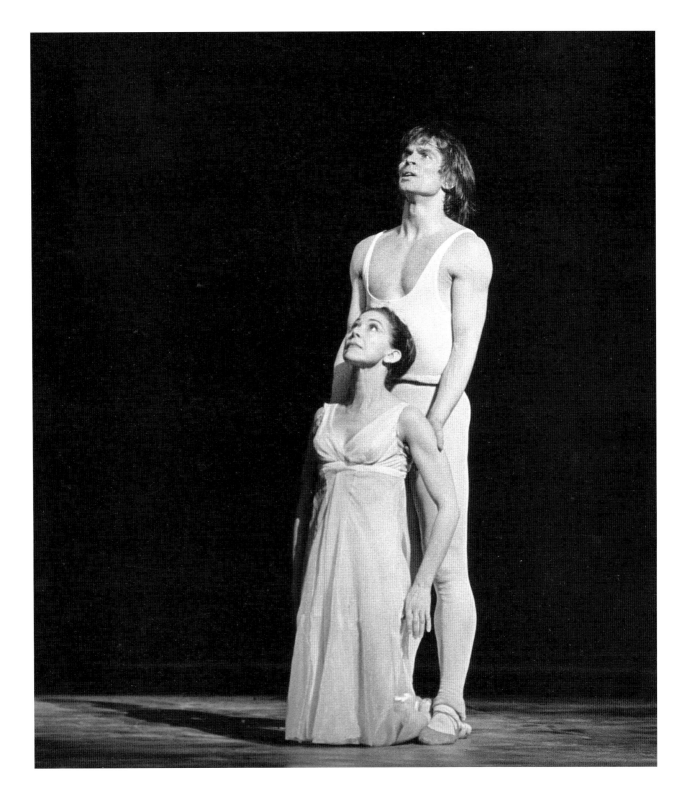

Fonteyn as Mélisande and Nureyev
as Pélléas in *Pélléas et Mélisande,* 1969

above and opposite: Fonteyn and Nureyev in *Paradise Lost*, 1967
Paradise Lost and *Pélléas et Mélisande* were created for Fonteyn and Nureyev and
The Royal Ballet by Roland Petit.

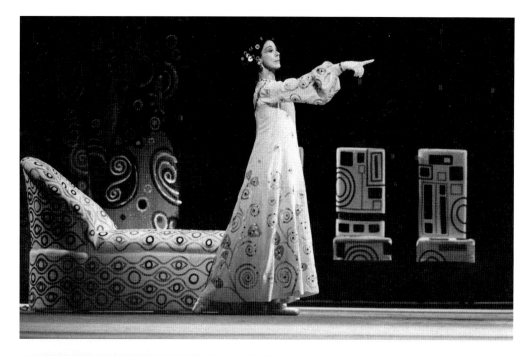

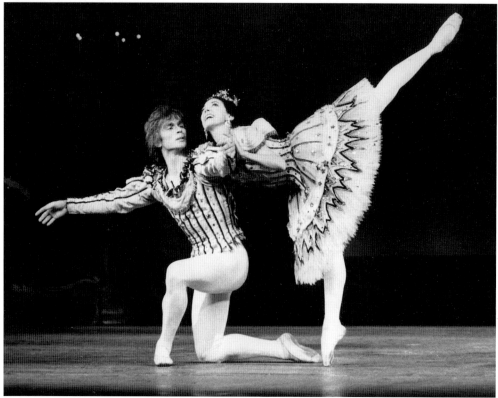

above: as The Diva in *Poème de L'Extase*, choreographed by John Cranko in 1972
below: Fonteyn and Nureyev in *Birthday Offering*, 1968, choreographed by Frederick Ashton

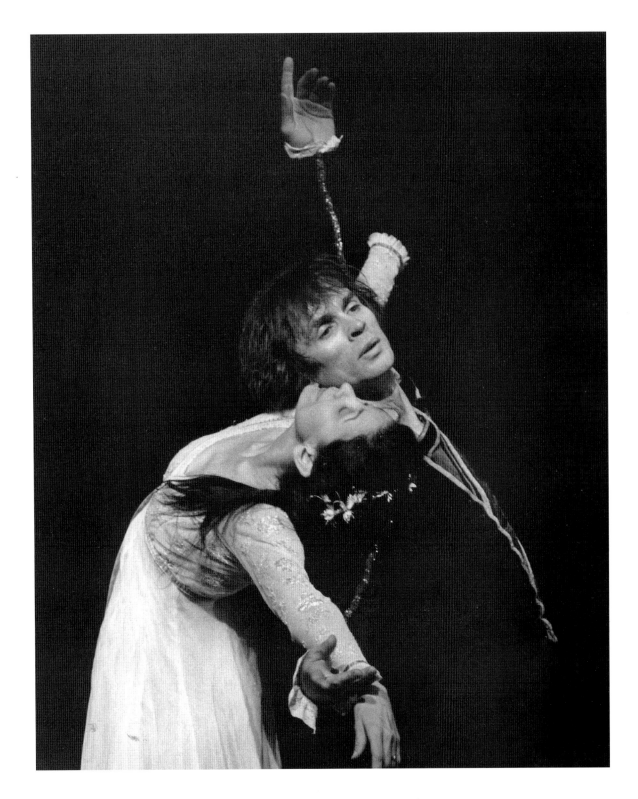

Fonteyn as Ophelia and Nureyev as Hamlet in
Hamlet with Ophelia, 1977, choreographed by Frederick Ashton

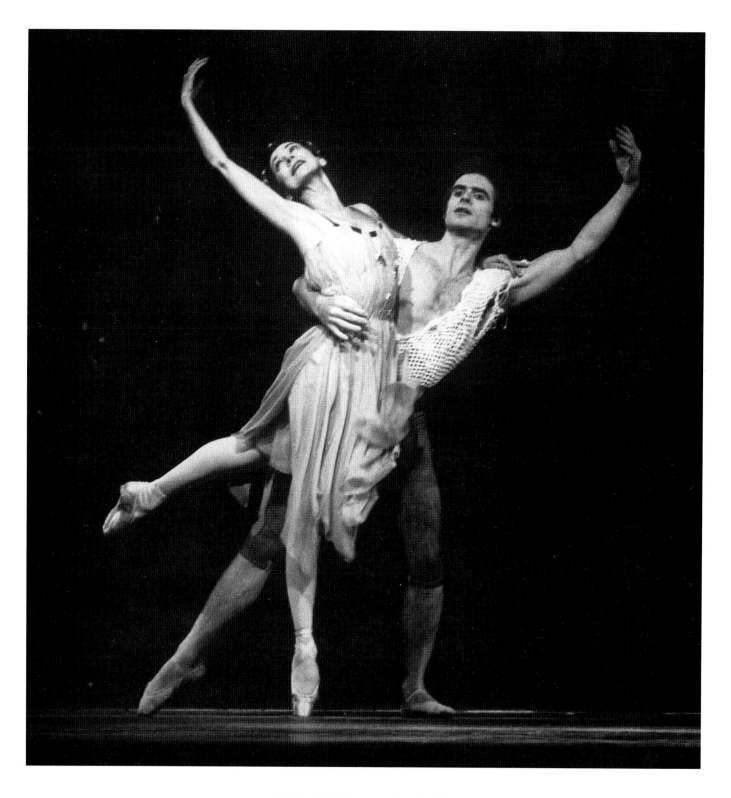

With David Wall in *Amazon Forest*, 1976

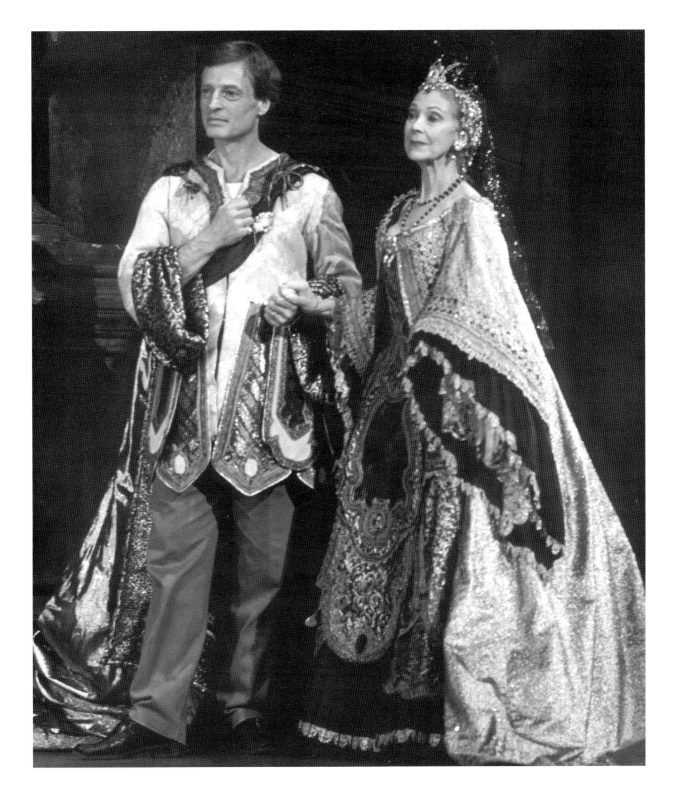

Desmond Kelly as The King and Fonteyn
as The Queen in rehearsal for *The Sleeping Beauty*, 1986
Fonteyn appeared with Sadler's Wells Royal Ballet in Miami
during an American tour.

REHEARSALS WITH NUREYEV, GALAS, TRIBUTES

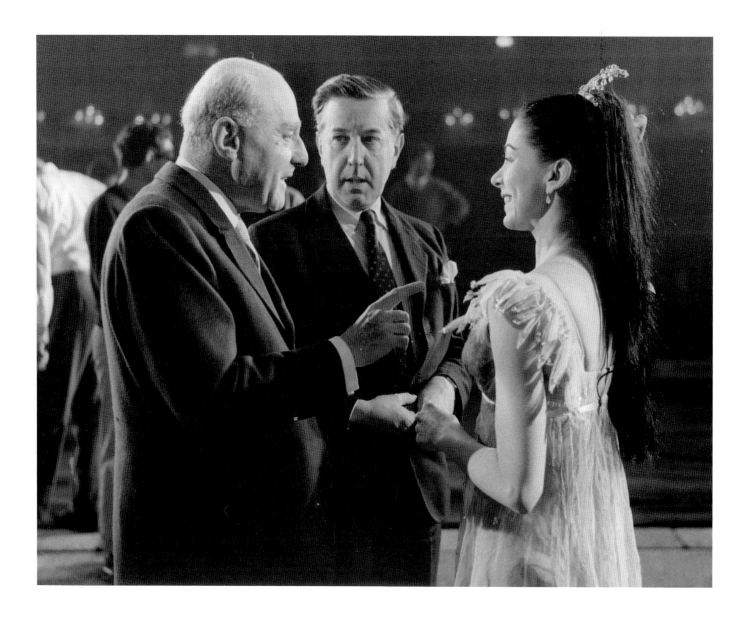

Paul Czinner, film director, Ashton and Fonteyn
during the filming of *Ondine* at the Royal Opera House, 1960

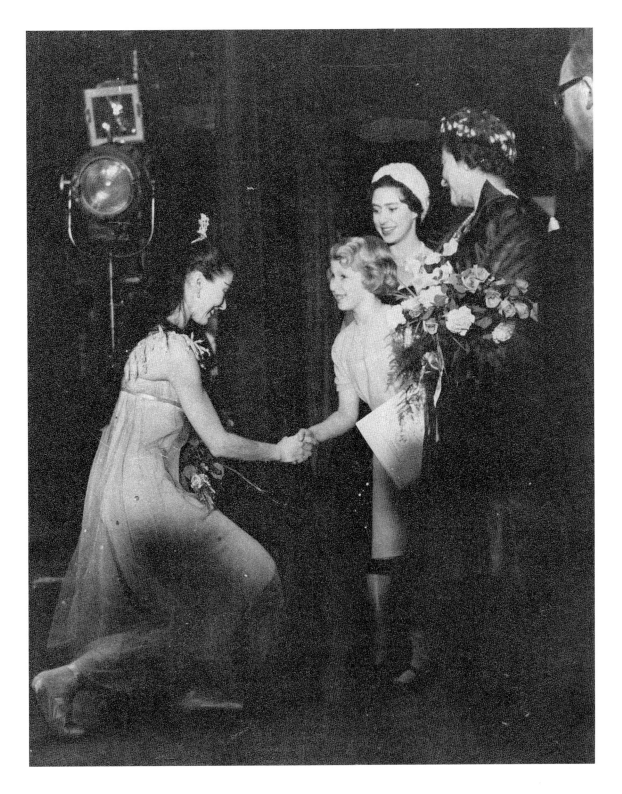

Margot Fonteyn with HRH The Princess Anne, HRH The Princess Margaret
and Her Majesty Queen Elizabeth The Queen Mother after a performance of *Ondine*

above: Fonteyn and Somes
on tour leaving Tokyo en route to New Zealand, 10 March 1959
below left: arriving in France
below right: signing autographs at the Stage Door
of the Royal Opera House, July 1966

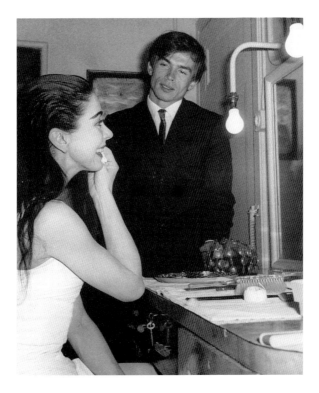

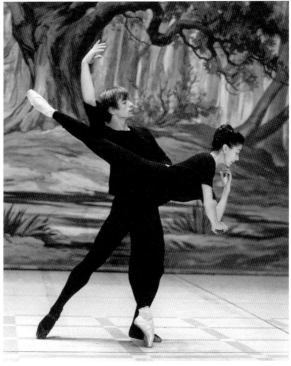

above: in costume for *Symphonic Variations,*
with Nureyev in her dressing room
below: with Nureyev in rehearsal
for *La Sylphide,* 1963

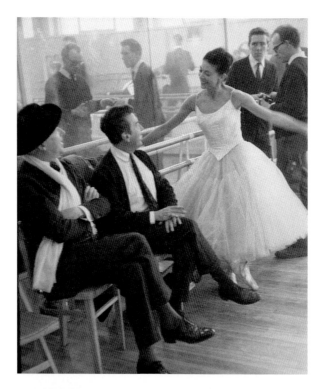

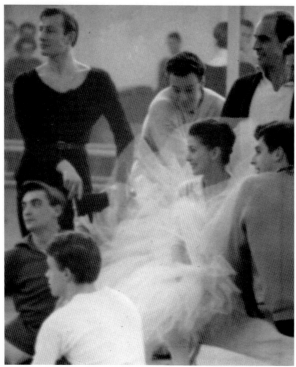

above: Cecil Beaton, Ashton and Fonteyn
during a rehearsal for *Marguerite and Armand*, 1963
below: a rehearsal for *Marguerite and Armand*, 1963

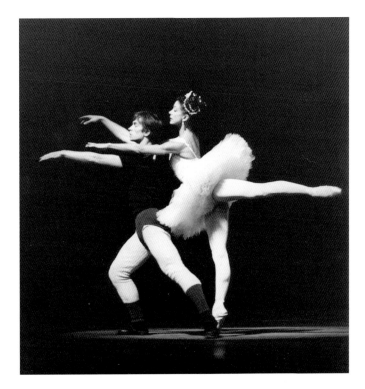

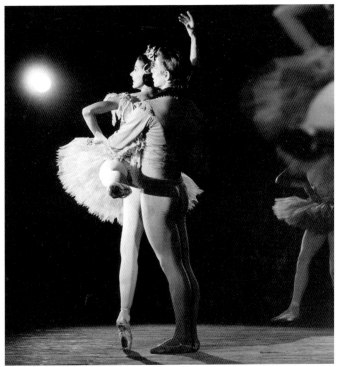

above: Fonteyn as Nikiya and Nureyev
as Solor during a rehearsal for *La Bayadère*, 1963
below: Fonteyn as Raymonda and Nureyev as Jean de Brienne
during a performance of *Raymonda*, Nice, 1964

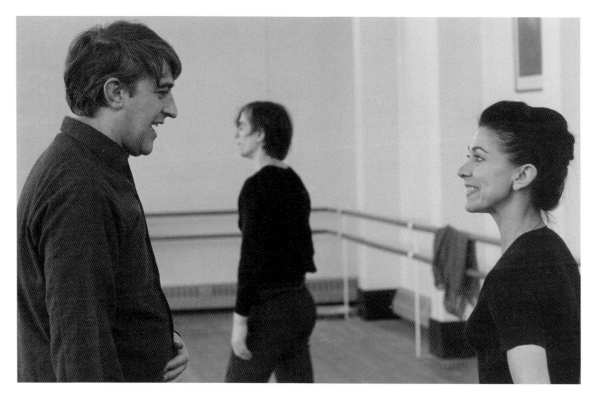

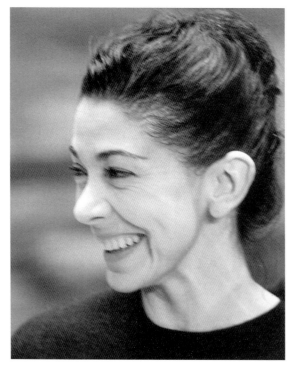

above: choreographer Kenneth MacMillan, Fonteyn as Juliet and Nureyev as Romeo
during rehearsals at The Royal Ballet School for *Romeo and Juliet*, 1965
below: during rehearsals

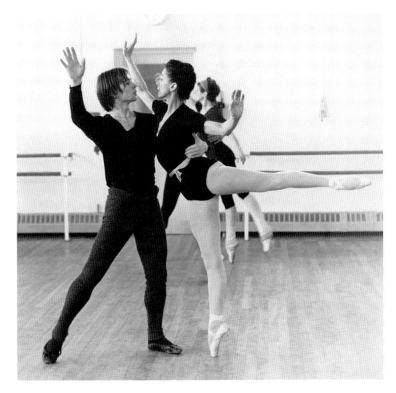

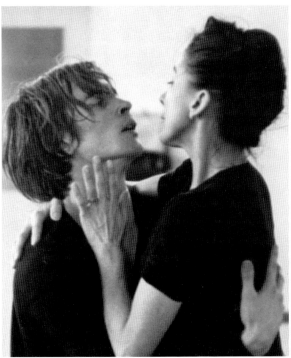

Nureyev and Fonteyn in rehearsal for *Romeo and Juliet*

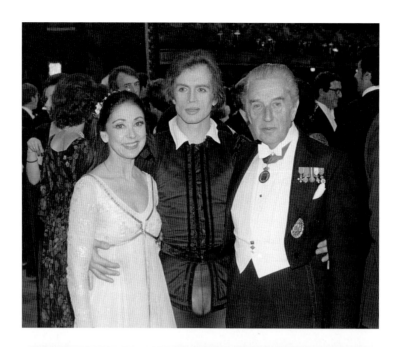

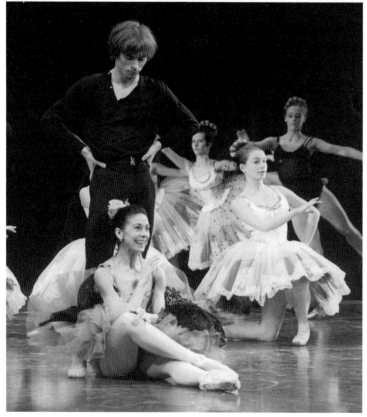

above: Fonteyn and Nureyev, in costume for *Hamlet Prelude*, with Ashton,
after the gala to celebrate the Silver Jubilee of Her Majesty Queen Elizabeth II, 1977
below: Fonteyn and Nureyev during a rehearsal for *Paquita* for the Royal Academy of Dancing (RAD)
Gala, 1963. Fonteyn was President of the RAD.

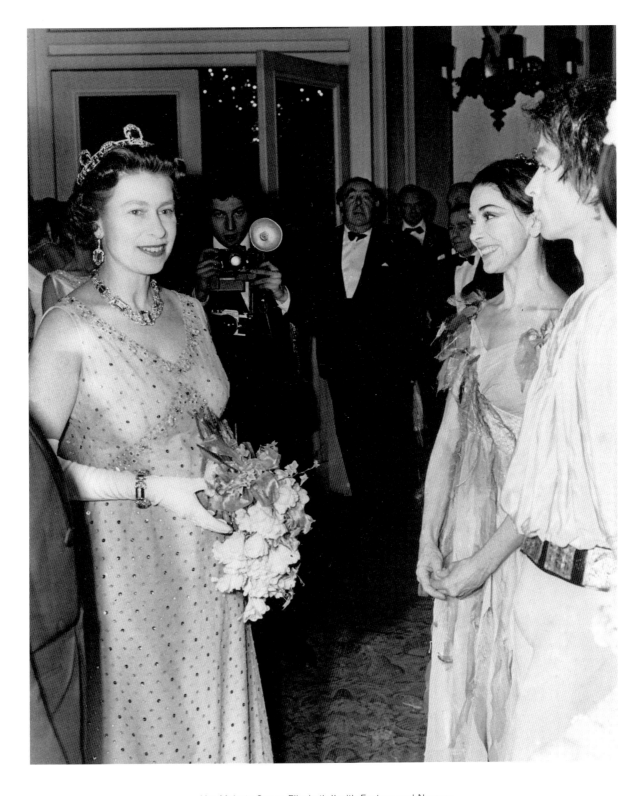

Her Majesty Queen Elizabeth II with Fonteyn and Nureyev
in costume for *Pélléas et Mélisande*, after the gala to celebrate Fonteyn's 35 years
with the Company, 26 March 1969

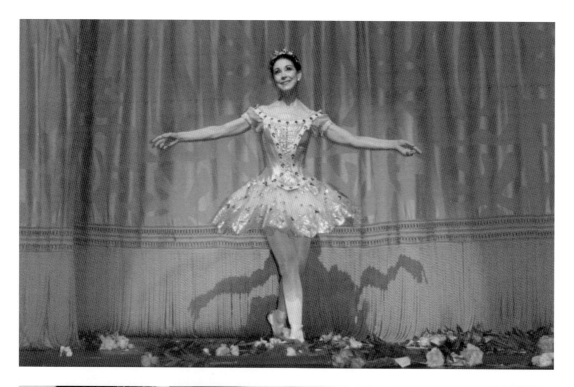

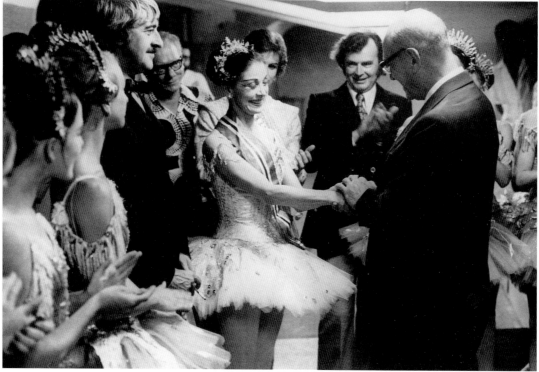

above: as Princess Aurora in *The Sleeping Beauty*, taking a curtain call
at the Metropolitan Opera House, New York, on the closing night of The Royal Ballet tour, 1972
below: Fonteyn being presented with a medal during The Royal Ballet's first tour
to Brazil (and South America) in 1973. Kenneth MacMillan can be seen on
the left and Peter Wright on the right.

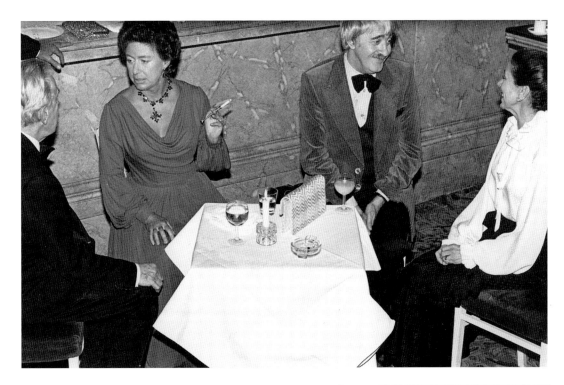

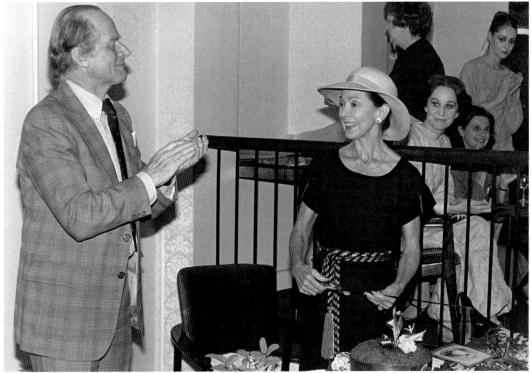

above: HRH The Princess Margaret, Kenneth MacMillan and Margot Fonteyn
at a reception after a performance of MacMillan's ballet *La Fin du jour*, 1979
below: John Tooley, General Director of the Royal Opera House, and Fonteyn
cutting the Taglioni cake, at the party which traditionally takes place
at the end of each season, 30 May 1981

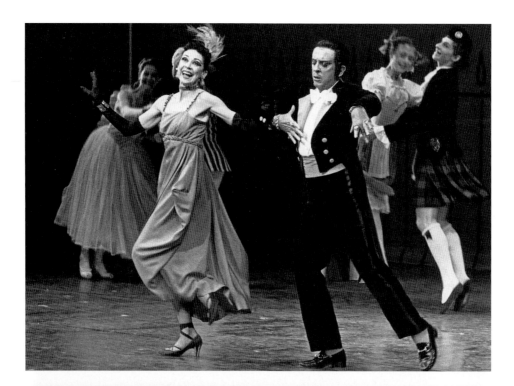

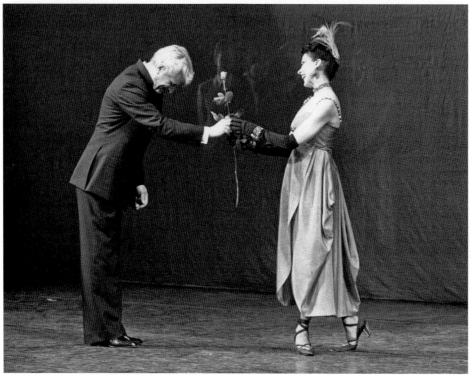

Margot Fonteyn's 60th birthday gala at the Royal Opera House, 1979
above: with Robert Helpmann in the *tango pasodoble* from *Façade*
Ninette de Valois always claimed there was nothing to beat 'the elegance of Margot and Bobby in *Façade*'
below: Michael Somes presents Margot Fonteyn with a rose
below opposite: curtain call

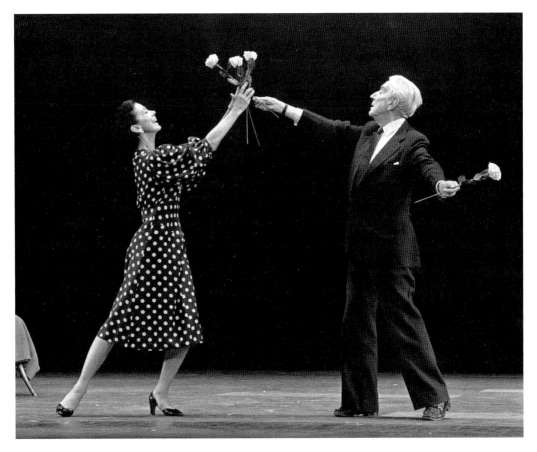

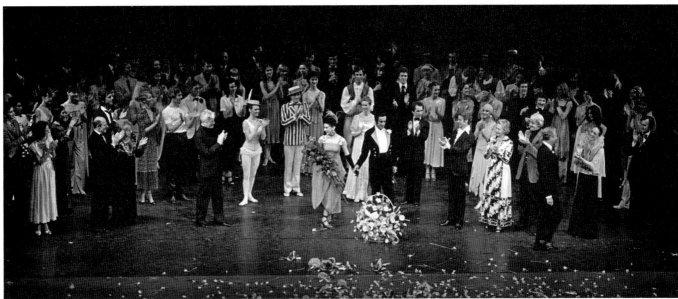

above: Fonteyn and Ashton in rehearsal for *Acte de présence* for
A Gala Tribute to Sir Frederick Ashton at the Royal Opera House, 18 October 1984

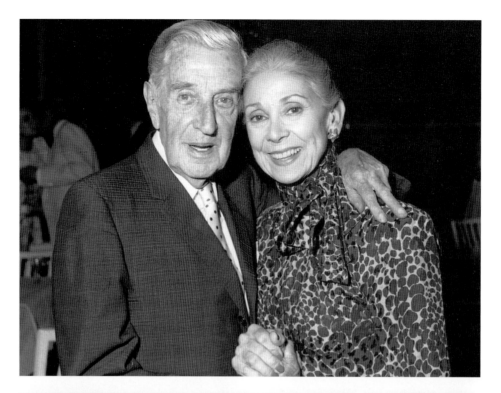

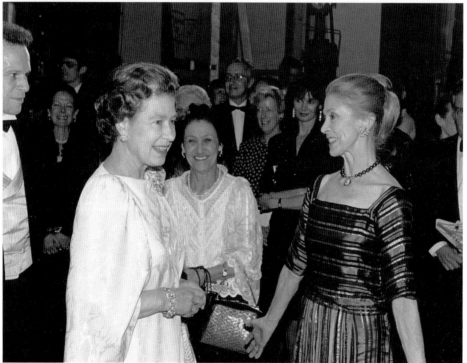

above: Ashton and Fonteyn at the Taglioni cake party, 3 July 1986
below: Her Majesty Queen Elizabeth II with Fonteyn after the gala to celebrate
Ninette de Valois' 90th birthday, 6 June 1988. Anthony Dowell can be seen on the left.

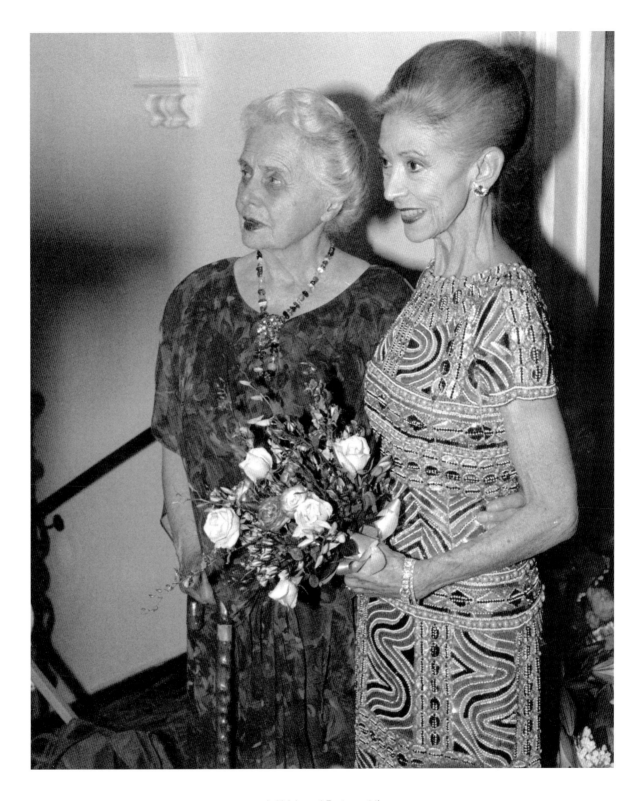

de Valois and Fonteyn at the
Tribute to Dame Margot Fonteyn, 30 May 1990

SELECTIVE CHRONOLOGY OF PERFORMANCES BY MARGOT FONTEYN WITH THE ROYAL BALLET

KEY: (m): music composed by
 (ch): choreography by
 (s): scenery designed by
 (c): costumes designed by
 (sc): scenery and costumes designed by
 (p): produced by
 (fp): first performance of the ballet
 (fpnp): first performance of a new production

1934

Accepted as a pupil with the Vic-Wells Ballet School and as a student began dancing in the *corps de ballet* of Vic-Wells Ballet

First appearance in a named role as Young Treginnis in
THE HAUNTED BALLROOM 1934 revival (m): Geoffrey Toye (ch): Ninette de Valois (sc): Motley

1935

Became a full member of Vic-Wells Ballet

First danced the Variations/Adagio of Lovers in
LES RENDEZVOUS 1935 revival (m): Daniel François Auber; arranged by Constant Lambert (ch): Frederick Ashton (sc): William Chappell

First danced the Mazurka in
LES SYLPHIDES 1935 revival (m): Frédéric Chopin (ch): Mikhail Fokine (sc): Léon Bakst

First danced Alicia in
THE HAUNTED BALLROOM 1935 revival (m): Geoffrey Toye (ch): Ninette de Valois (sc): Motley

First danced the Polka in
FAÇADE (m): William Walton (ch): Frederick Ashton (sc): John Armstrong (fp): Vic-Wells Ballet, Sadler's Wells Theatre, 8 October 1935

First danced Odette, with Ruth French as Odile, in
LE LAC DES CYGNES 1935 revival (m): Piotr Ilyich Tchaikovsky (ch): Marius Petipa (p): Nicholas Sergeyev (sc): Hugh Stevenson

First danced the role of the Creole Girl with William Chappell as the Creole Boy in
RIO GRANDE (m): Constant Lambert, poem: Sacheverell Sitwell (ch): Frederick Ashton (sc): Edward Burra (fp): Vic-Wells Ballet, Sadler's Wells Theatre, 26 March 1935

Created the role of His Fiancée in
LE BAISER DE LA FÉE (m): Igor Stravinsky (ch): Frederick Ashton (sc): Sophie Fedorovitch (fp): Vic-Wells Ballet, Sadler's Wells Theatre, 26 November 1935

1936

Created the role of the Woman in Ball Dress in
APPARITIONS (m): Franz Liszt, arranged by Constant Lambert, orchestrated by Gordon Jacob (ch): Frederick Ashton (sc): Cecil Beaton (fp): Vic-Wells Ballet, Sadler's Wells Theatre, 11 February 1936

Created the role of A Flower Girl in
NOCTURNE (m): Frederick Delius (ch): Frederick Ashton (sc): Sophie Fedorovitch (fp): Vic-Wells Ballet, Sadler's Wells Theatre, 10 November 1936

First danced Princess Aurora in the Act III *pas de deux* from
THE SLEEPING PRINCESS 1936 revival on tour (m): Piotr Ilyich Tchaikovsky (ch): Marius Petipa (c): William Chappell

1937

First *Giselle* with Robert Helpmann
GISELLE 1937 revival (m): Adolphe Adam (ch): after Jean Coralli (p): Nicholas Sergeyev (sc): William Chappell

Created the *pas de deux* with Robert Helpmann in
LES PATINEURS (m): Giacomo Meyerbeer, arranged by Constant Lambert (ch): Frederick Ashton (sc): William Chappell (fp): Vic-Wells Ballet, Sadler's Wells Theatre, 16 February 1937

First danced the Sugar Plum Fairy in
CASSE-NOISETTE 1937 revival (m): Piotr Ilyich Tchaikovsky (ch): Marius Petipa (sc): Hedley Briggs

First danced Pomona in
POMONA 1937 revival (m): Constant Lambert (ch): Frederick Ashton (sc): John Banting

Created the role of Julia in
A WEDDING BOUQUET (m): Lord Berners, libretto: Gertrude Stein (ch): Frederick Ashton (sc): Lord Berners (fp): Vic-Wells Ballet, Sadler's Wells Theatre, 27 April 1937

First danced Odette and Odile in
LE LAC DES CYGNES 1937 revival (m): Piotr Ilyich Tchaikovsky (ch): Marius Petipa (p): Nicholas Sergeyev (sc): Hugh Stevenson

1938

Created the role of The Young Woman with Michael Somes as The Young Man in
HOROSCOPE (m): Constant Lambert (ch): Frederick Ashton (sc): Sophie Fedorovitch (fp): Vic-Wells Ballet, Sadler's Wells Theatre, 27 January 1938

First danced Venus in
THE JUDGEMENT OF PARIS 1938 (m): Lennox Berkeley (ch): Frederick Ashton (sc): William Chappell

1939

Danced Princess Aurora in the Vic-Wells Ballet's first full-length production of
THE SLEEPING PRINCESS (m): Piotr Ilyich Tchaikovsky (ch): Marius Petipa (p): Nicholas Sergeyev (sc): Nadia Benois (fp): Sadler's Wells Ballet, Sadler's Wells Theatre, 2 February 1939

First danced A Debutante in
FAÇADE 1939 revival on tour (m): William Walton (ch): Frederick Ashton (sc): John Armstrong

1940

Created with Michael Somes the central roles as Children of Light in
DANTE SONATA (m): Franz Liszt, orchestrated by Constant Lambert (ch): Frederick Ashton (sc): Sophie Fedorovitch, after John Flaxman (fp): Vic-Wells Ballet, Sadler's Wells Theatre, 23 January 1940

1941

Created the female lead in
THE WANDERER (m): Franz Schubert (ch): Frederick Ashton (sc): Graham Sutherland (fp): Sadler's Wells Ballet, New Theatre, 27 January 1941

1942

Created the role of Ophelia in
HAMLET (m): Piotr Ilyich Tchaikovsky (ch): Robert Helpmann (sc): Leslie Hurry (fp): Sadler's Wells Ballet, New Theatre, 19 May 1942

First danced the role of The Betrayed Girl in
THE RAKE'S PROGRESS 1942 revival (m): Gavin Gordon (ch): Ninette de Valois (sc): Rex Whistler, after Hogarth

1943

Created the role of Una in
THE QUEST (m): William Walton (ch): Frederick Ashton (sc): John Piper (fp): Sadler's Wells Ballet, New Theatre, 6 April 1943

1944

First danced The Young Girl in a new production of
LE SPECTRE DE LA ROSE (m): Carl Maria von Weber (ch): Mikhail Fokine (sc): Rex Whistler (fp): Sadler's Wells Ballet, Theatre Royal Newcastle, 24 April 1944

1946

Danced Princess Aurora with Robert Helpmann as Prince Florimund in the new production of
THE SLEEPING BEAUTY (m): Piotr Ilyich Tchaikovsky (ch): after Marius Petipa (p): Nicholas Sergeyev (sc): Oliver Messel (fp): Sadler's Wells Ballet, Royal Opera House, 20 February 1946. This was the first night in Sadler's Wells Ballet's new home.

Created the central female role with Michael Somes as the male lead in
SYMPHONIC VARIATIONS (m): César Franck (ch): Frederick Ashton (sc): Sophie Fedorovitch (fp): Sadler's Wells Ballet, Royal Opera House, 24 April 1946

Danced Giselle at the Royal Opera House with Alexis Rassine as Count Albrecht in a new production of
GISELLE (m): Adolphe Adam (ch): after Jean Coralli (p): Nicholas Sergeyev (sc): James Bailey (fp): Sadler's Wells Ballet, Royal Opera House, 12 June 1946

Created the role of La Bolero in
LES SIRÈNES (m): Lord Berners, orchestrated by Roy Douglas (ch): Frederick Ashton (sc): Cecil Beaton (fp): Sadler's Wells Ballet, Royal Opera House, 12 November 1946

Danced Odette and Odile at the Royal Opera House, with Robert Helpmann as Prince Siegfried in a revised production of
LE LAC DES CYGNES (m): Piotr Ilyich Tchaikovsky (ch): after Marius Petipa, (p): Nicholas Sergeyev (sc): Leslie Hurry (fp): Sadler's Wells Ballet, Royal Opera House, 19 December 1946

1947

First danced The Miller's Wife with Léonide Massine as The Miller in
THE THREE-CORNERED HAT (m): Manuel de Falla (ch): Léonide Massine (sc): Pablo Picasso (fp): Sadler's Wells Ballet, Royal Opera House, 6 February 1947

First danced Mam'zelle Angot in
MAM'ZELLE ANGOT (m): Charles Lecocq, orchestrated by Gordon Jacob (ch): Léonide Massine (sc): André Derain (fp): Sadler's Wells Ballet, Royal Opera House, 26 November 1947

1948

Created the central female role in
SCÈNES DE BALLET (m): Igor Stravinsky (ch): Frederick Ashton (sc): André Beaurepaire (fp): Sadler's Wells Ballet, Royal Opera House, 11 February 1948

First *Giselle* with Michael Somes
GISELLE 1948 revival (m): Adolphe Adam (ch): after Jean Coralli (p): Nicholas Sergeyev (sc): James Bailey

First *Le Lac des cygnes* with Michael Somes
LE LAC DES CYGNES 1948 revival (m): Piotr Ilyich Tchaikovsky (ch): after Marius Petipa (p): after Nicholas Sergeyev (sc): Leslie Hurry

Created the role of La Morte amoureuse in
DON JUAN (m): Richard Strauss (ch): Frederick Ashton (sc): Edward Burra (fp): Sadler's Wells Ballet, Royal Opera House, 25 November 1948

1949

First danced Cinderella with Michael Somes as The Prince in
CINDERELLA 1949 revival (m): Serge Prokofiev (ch): Frederick Ashton (sc): Jean-Denis Malclès

1950

Created the role of The Lady Dulcinea (Aldonza Lorenzo) in
DON QUIXOTE (m): Roberto Gerhard (ch): Ninette de Valois (sc): Edward Burra (fp): Sadler's Wells Ballet, Royal Opera House, 20 February 1950

First danced the central female role in
BALLET IMPERIAL (m): Piotr Ilyich Tchaikovsky (ch): George Balanchine (sc): Eugene Berman (fp): Sadler's Wells Ballet, Royal Opera House, 5 April 1950

1951

Created the role of Chloë with Michael Somes as Daphnis in
DAPHNIS AND CHLOË (m): Maurice Ravel (ch): Frederick Ashton (sc): John Craxton (fp): Sadler's Wells Ballet, Royal Opera House, 5 April 1951

Created the role of the female Tiresias in
TIRESIAS (m): Constant Lambert (ch): Frederick Ashton (sc): Isabel Lambert (fp): Sadler's Wells Ballet, Royal Opera House, 9 July 1951

1952

Created the role of Sylvia in
SYLVIA (m): Léo Delibes (ch): Frederick Ashton (sc): Robin and Christopher Ironside (fp): Sadler's Wells Ballet, Royal Opera House, 3 September 1952

1953

Created the role of The Queen of the Air in
HOMAGE TO THE QUEEN
THE CORONATION BALLET (m): Malcolm Arnold (ch): Frederick Ashton (sc): Oliver Messel (fp): Sadler's Wells Ballet, Royal Opera House, 2 June 1953

1954

Danced The Firebird in
THE FIREBIRD (m): Igor Stravinsky (ch): Mikhail Fokine (p): Serge Grigoriev, Lubov Tchernicheva (sc): Natalia Gontcharova (fp): Sadler's Wells Ballet, Empire Theatre, Edinburgh, 23 August 1954

1956

Created the central female role in
BIRTHDAY OFFERING (m): Alexander Glazunov, arranged by Robert Irving (ch): Frederick Ashton (s): Sophie Fedorovitch (from Veneziana) (c): André Levasseur (fp): Sadler's Wells Ballet, Royal Opera House, 5 May 1956

1957

First danced The Ballerina in
PETRUSHKA (m): Igor Stravinsky (ch): Mikhail Fokine (p): Sergey Grigoriev, Lubov Tchernicheva (sc): Alexandre Benois (fp): The Royal Ballet, Royal Opera House, 26 March 1957

1958

Created the role of the Ondine in
ONDINE (m): Hans Werner Henze (ch): Frederick Ashton (sc): Lila de Nobili (fp): The Royal Ballet, Royal Opera House, 27 October 1958

1960

Created the role of Raymonda in
RAYMONDA, SCÈNE D'AMOUR (m): Alexander Glazunov (ch): Frederick Ashton (c): Leslie Hurry (fp): The Royal Ballet, Royal Opera House, 1 March 1960

Danced Giselle with Michael Somes as Count Albrecht in a new production of
GISELLE (m): Adolphe Adam (ch): Jean Coralli, Jules Perrot revised Nicholas Sergeyev, Frederick Ashton (p): Frederick Ashton, Tamara Karsavina (fp): The Royal Ballet, Metropolitan Opera House, New York, 30 September 1960

1962

First *Giselle* with Rudolf Nureyev
GISELLE 1962 revival (m): Adolphe Adam (ch): Jean Coralli, Jules Perrot revised Nicholas Sergeyev, Frederick Ashton (p): Frederick Ashton, Tamara Karsavina (sc): James Bailey

Danced with Rudolf Nureyev in
LE CORSAIRE *pas de deux* (m): Drigo Minkus, orchestrated by John Lanchbery (ch): after Marius Petipa (c): André Levasseur (fp): The Royal Ballet, Royal Opera House, 3 November 1962

1963

Danced Odette and Odile with David Blair as Prince Siegfried in a new production of
SWAN LAKE (m): Piotr Ilyich Tchaikovsky (ch): Marius Petipa, Lev Ivanov (p): Robert Helpmann (sc): Carl Toms (fp): The Royal Ballet, Royal Opera House, 12 December 1963

Created the role of Marguerite with Rudolf Nureyev as Armand in
MARGUERITE AND ARMAND (m): Franz Liszt, orchestrated by Humphrey Searle (ch): Frederick Ashton (sc): Cecil Beaton (fp): The Royal Ballet, Royal Opera House, 12 March 1963

First danced Nikiya in
LA BAYADÈRE Act III *The Kingdom of the Shades* (m): Ludwig Minkus (ch): Marius Petipa (p): Rudolf Nureyev (c): Philip Prowse (fp): The Royal Ballet, Royal Opera House, 27 November 1963

1965

Created the role of Juliet with Rudolf Nureyev as Romeo in
ROMEO AND JULIET (m): Serge Prokofiev (ch): Kenneth MacMillan (sc): Nicholas Georgiadis (fp): The Royal Ballet, Royal Opera House, 9 February 1965

First *Cinderella* with David Blair as the Prince in a new production of
CINDERELLA (m): Serge Prokofiev (ch): Frederick Ashton (sc): Henry Bardon, David Walker (fp): The Royal Ballet, Royal Opera House, 23 December 1965

1967

Created the role of The Woman in
PARADISE LOST (m): Marius Constant (ch): Roland Petit (sc): Martial Raysse (fp): The Royal Ballet, Royal Opera House, 23 February 1967

1969

Danced Raymonda with Rudolf Nureyev as Jean de Brienne in
RAYMONDA Act III 1969 revival (m): Alexander Glazunov (ch): Rudolf Nureyev after Marius Petipa (sc): Barry Kay

Created the role of Mélisande with Rudolf Nureyev as Pélléas in
PÉLLÉAS ET MÉLISANDE (m): Arnold Schoenberg (ch): Roland Petit (sc): Jacques Dupont (fp): at the gala to celebrate Margot Fonteyn's 35 years with the Royal Ballet, Royal Opera House, 26 March 1969

1972

Danced Princess Aurora with Rudolf Nureyev as Prince Florimund in
THE SLEEPING BEAUTY 1972 tour (m): Piotr Ilyich Tchaikovsky (ch): after Marius Petipa (p): Peter Wright (s): Henry Bardon (c): Lila de Nobili/ Rostislav Doboujinsky. Including the last night of The Royal Ballet tour to the Metropolitan Opera House, New York, 3 June 1972

Created the role of The Diva in
POÈME DE L'EXTASE (m): Alexander Scriabin (ch): John Cranko (sc): Jürgen Rose after Gustav Klimt (fp): The Royal Ballet, Royal Opera House, 15 February 1972

1975

Created with Rudolf Nureyev
DON JUAN *pas de deux* (m): Christopher Gluck, Thomas Luis de Victoria (ch): John Neumeier (c): Filippo Sanjust, Anthony Dowell (fp): The Royal Ballet, Royal Opera House, 4 March 1975

1976

Created with David Wall
AMAZON FOREST *pas de deux* (m): Hector Villa-Lobos (ch): Frederick Ashton (c): José Varona (fp): The Royal Ballet, Royal Opera House, 23 November 1976

1977

Created the role of Ophelia with Rudolf Nureyev as Hamlet in
HAMLET PRELUDE *pas de deux* later toured as **HAMLET WITH OPHELIA** (m): Franz Liszt (ch): Frederick Ashton (c): Carl Toms (fp): The Royal Ballet, Royal Opera House, 30 May 1977

1979

Created the role, with Frederick Ashton, of
SALUT D'AMOUR À MARGOT FONTEYN (m): Edward Elgar (ch): Frederick Ashton (c): William Chappell (fp): at the gala to celebrate Margot Fonteyn's 60th birthday, Royal Opera House, 23 May 1979. Fonteyn also appeared as A Debutante with Robert Helpmann as The Dago in *Façade*. After the gala, HRH The Princess Margaret, President of The Royal Ballet, announced that the Board and General Administrator of the Royal Opera House had decided to award Margot Fonteyn the title of *Prima Ballerina Assoluta*, the first and only time the title has been awarded in this country.

1984

Created the role, with Frederick Ashton, of
ACTE DE PRÉSENCE (m): Piotr Ilyich Tchaikovsky from *The Sleeping Beauty* (ch): Frederick Ashton (fp): Gala, Metropolitan Opera House, New York, 13 May 1984; revived for the *Gala Tribute to Sir Frederick Ashton* to celebrate his 80th birthday, Royal Opera House, 18 October 1984.

1986

Appeared as The Queen in
THE SLEEPING BEAUTY (m): Piotr Ilyich Tchaikovsky (ch): after Marius Petipa (p): Peter Wright (sc): Philip Prowse
Sadler's Wells Royal Ballet tour to Miami, 1986

Margot Fonteyn died on 21 February 1991 at the age of 71.